To: Ro...

IMAGES
of America

JUPITER

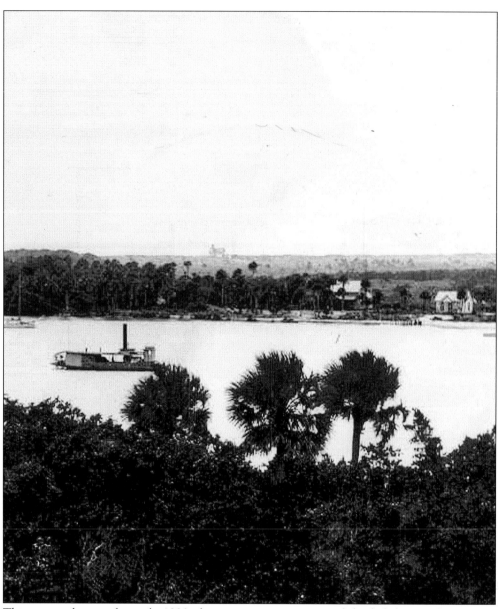

This view, taken in the early 1890s from a survey tower east of the lighthouse, shows, from left to right, the rockledge; a paddle wheel steamer captained by Richard Paddison; the Carlin home; the Hooley home, which became the Sperry home at Suni Sands; and the United States Lifesaving Station at Jupiter on the horizon. Notice that there were no Australian pine trees at that time, just palmetto, coconut, and sabal palms. (Courtesy of William Carlin White Collection.)

On the cover In 1891, Seminole Indians Cypress Tiger, Jimmy Gopher, and Billy Stuart allowed William Henry Jackson to photograph them standing on the dock of the Jupiter & Lake Worth Railroad, better known as the "Celestial Railroad" for its stops at Jupiter, Venus, Mars, and Juno. Mr. Jackson, a photographer for the Detroit Publishing Company, was a guest at the Carlin House. (Courtesy of Skip Gladwin Collection.)

IMAGES
of America

JUPITER

Lynn Lasseter Drake and William Carlin White

ARCADIA

Published by Arcadia Publishing
an imprint of Tempus Publishing Inc.
Charleston SC, Chicago, Portsmouth NH, San Francisco

Printed in Great Britain

Library of Congress Catalog Card Number: 2003109966

For all general information contact Arcadia Publishing at:
Telephone 843-853-2070
Fax 843-853-0044
E-mail sales@arcadiapublishing.com
For customer service and orders:
Toll-Free 1-888-313-2665

Visit us on the internet at http://www.arcadiapublishing.com

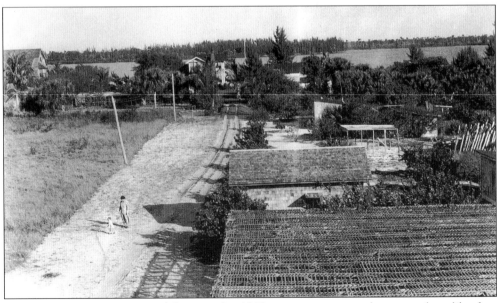

Turner Quay Fernery, pictured here in the 1930s, grew asparagus plumosa, a lace like fern originally imported from Italy that was able to withstand shipment by train to northern florists. (Courtesy of William Carlin White Collection.)

CONTENTS

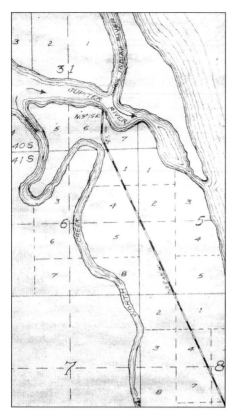

This Plat Map of the Jupiter & Lake Worth Railway was recorded in Dade County in 1895. It shows the inlet location at that time and the natural waterway going south prior to the dredging of the East Coast Canal Line that later became the Intracoastal Waterway. The railway continued south to the headwaters of Lake Worth, where passengers continued south by water.

ACKNOWLEDGMENTS

We would like to acknowledge the following for their generous contributions of time and material: Ms. Jamie Stuve, executive director of the Loxahatchee River Historical Society; Michael Zaidman, curator of the Loxahatchee River Historical Society; Mr. Skip Gladwin; Beverly Spencer Branco; Mr. James Snyder; the Florida State Archives; and the descendants of Mr. L.M. Davis of Limestone Creek.

INTRODUCTION

Jupiter Inlet is one of Florida's oldest recorded areas. It is probable that no other location on the east coast of the United States enjoys the international reputation for guiding ships throughout the centuries as does the area now known as Jupiter. This location protrudes farther out into the Atlantic Ocean, relatively speaking, than any other point along the east coast. For this reason it has guided ships of all kinds, from about 1550 to present day. The strong, northbound current of the gulf stream passed closer to Jupiter than anywhere else on the east coast of the United States, bringing many ships toward its treacherous inlet and sending some of them to their demise on its shores. The large volume of shipwrecks in this area led to the construction of Jupiter Lighthouse in 1853 as a navigational aid to help prevent such disasters. The early pioneer settlement of Jupiter began when the light was first lit on July 10, 1860. It was a desolate existence for its keepers and their families.

In 1884, the United States government sold 124 acres of the Fort Jupiter Reservation to Sarah Gleason. This was the first and only sale of the reservation land prior to its release for homesteading. In 1885, Captain Carlin purchased ten acres of the Gleason land and started construction of the first permanent private home in the area, the Carlin House. The Carlin, DuBois, Hooley, and Sperry families were some of the first families to settle on the south side of the Loxahatchee River beginning in 1885. In July 1894, the Fort Jupiter reservation was opened to homesteading and settlement began on the north side of the river.

In 1885, Capt. Charles R. Carlin received an appointment to become the one and only captain of the United States Lifesaving Station in Jupiter. The Lifesaving Station was built in 1886 to aid ships in distress and the victims of shipwrecks. Pioneers and Seminoles appeared when a ship lost its cargo, salvaging wood, staples, clothing, and any other items that would aid in their survival.

Still an important communications center at the turn of the century, the busy area around the lighthouse, which sat high on a hill overlooking the inlet, held an oil house, keeper's quarters, several outbuildings and docks, the United States Wireless Telegraph Station, and the United States Weather Bureau. The original lighthouse keeper's home burned down in 1927. Jupiter remained a small fishing and tourist community through the late 1950s when United Technologies opened and steadily, more and more people came to the area. The Coast Guard took over the lighthouse property several years before and eventually the remaining buildings were taken down to provide room for military housing.

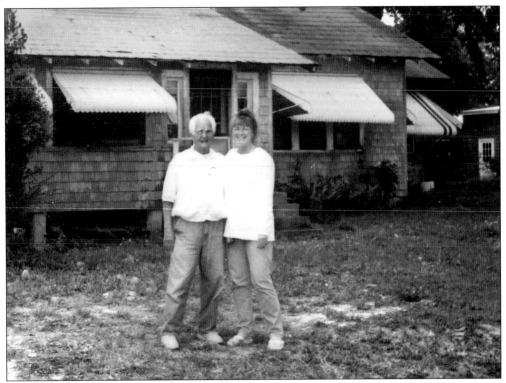

Carlin White and Lynn Lasseter Drake are pictured in front of Carlin's mother's home on the Loxahatchee River at Turner Quay in May 2000.

William Carlin White was born in the Carlin House in August of 1907, the son of William Arthur White and Emily Carlin White Turner, and grandson of Mary Moorer Joyner Carlin and Capt. Charles Robert Carlin. Mr. White married Lillian M. Oswald of Long Island on the 21st of December 1938. Retiring from the navy after 30 years, the Whites moved back to Jupiter in August of 1969. Mr. White went on to become mayor of the Town of Jupiter from 1970 to 1976. Carlin White has written two histories, *History of the Carlin House* and *History of the Jupiter Wireless Telegraph Station*, and has been the caretaker of the old Carlin House collection of photographs and memorabilia.

Lynn Lasseter Drake, a genealogist and historical researcher, has been collecting information on Jupiter area pioneers and their descendants since the early 1980s. This project is ongoing. The Lasseter family moved to Suni Sands in late 1959. Frank Lasseter left what is now Lockheed Martin Aeronautics Company in Marietta, Georgia, to work at Pratt & Whitney Aircraft in Palm Beach County. Suni Sands is one of the very few places that has not changed much since that time.

One
JUPITER INLET LIGHT STATION

Jupiter Inlet Lighthouse is the oldest existing structure in Palm Beach County. Congress appropriated $35,000 in 1853 to erect a lighthouse to mark the reef lying just off Jupiter Inlet and to guide the vessels as a landfall. Lt. George G. Meade selected the site and designed the tower. The lighthouse was completed in 1859 at a cost of $60,859.98. Thomas Twiner was appointed the first keeper of Jupiter Light Station when it was lit on July 10, 1860.

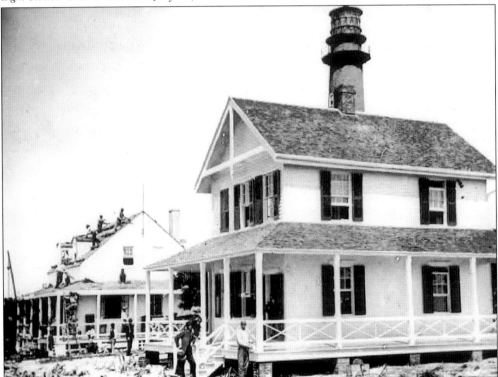

By 1880, the one lighthouse keeper's dwelling became too small for the three keepers and their families. It was also in need of extensive repairs. In 1883, the United States government dispatched a crew of men to repair the lighthouse keeper's quarters (shown in the left of the photograph) and to build a new, two-story dwelling for the personnel on the property. (Courtesy of Florida State Archives. Photo by Melville E. Spencer.)

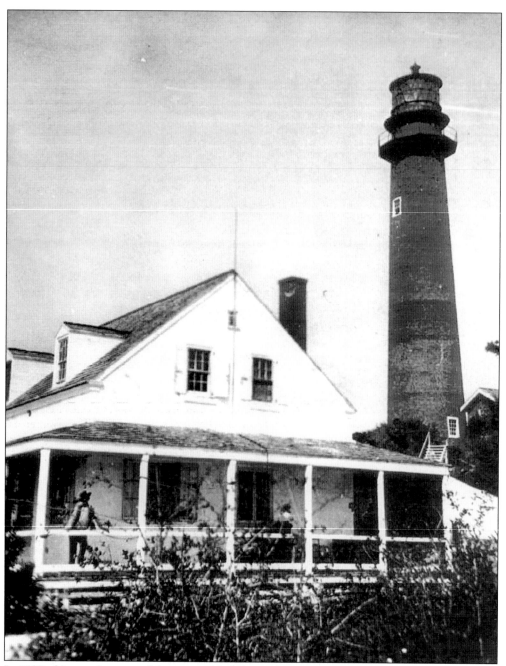

In 1883, this was the view of the original lighthouse keeper's house prior to the renovations. By 1856, there was much trouble during construction of the tower with Seminole Indians, sickness from mosquitoes, and the scheduled arrival of supplies and building materials. Seminoles actually shot at the workmen from the cover of the surrounding vegetation. Different shades of the layers of brick can be seen, which marked the junctures where construction ceased and resumed. Work was resumed in December of 1858. (Courtesy of Florida State Archives. Photo by Melville E. Spencer.)

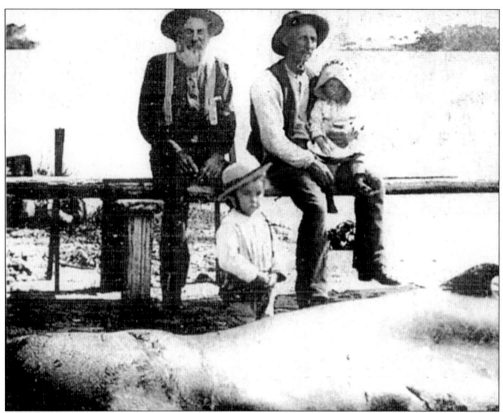

James Armour holds his infant daughter while a young boy poses around 1886. The children are probably Bertha and Will Armour. Spencer described the animal in the foreground as a sea cow or manatee, but it was most likely a small whale. (Courtesy of Spencer Family Collection. Photo by Melville E. Spencer.)

This Florida panther was killed and recorded by Capt. James Armour in 1879. The panther, weighing 106 pounds and measuring 6 feet 8 inches, had tried to attack one of Armour's pigs near the house. (Courtesy of Spencer Family Collection. Photo by Melville E. Spencer.)

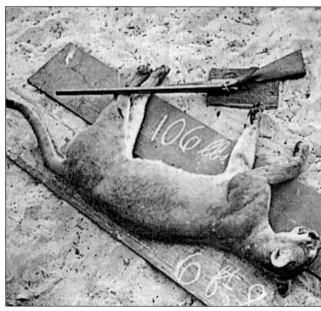

The crew dispatched by the U.S. Government to repair the original lighthouse keeper's quarters in 1883 can be seen at the original lighthouse keeper's quarters with lighthouse personnel. The original keeper's house burned down in 1927. A dragonfly can be seen in top left of the photograph. (Courtesy of Lynn Drake Collection. Photo by Melville E. Spencer.)

Lighthouse supply boats deliver oil to the Jupiter Lighthouse, *c.* 1901. The buoy tender anchored offshore and they used these boats to deliver the supplies to shore. Harry DuBois and later his son, John, organized the ransportation of these supplies to the lighthouse. (Courtesy of Florida State Archives.)

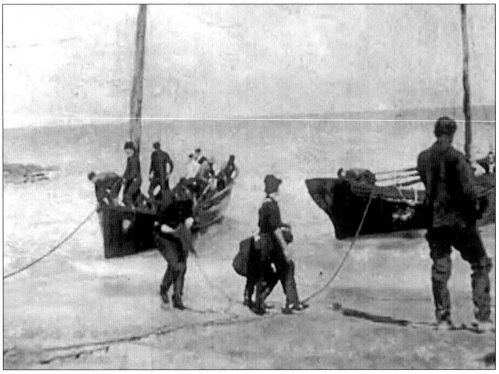

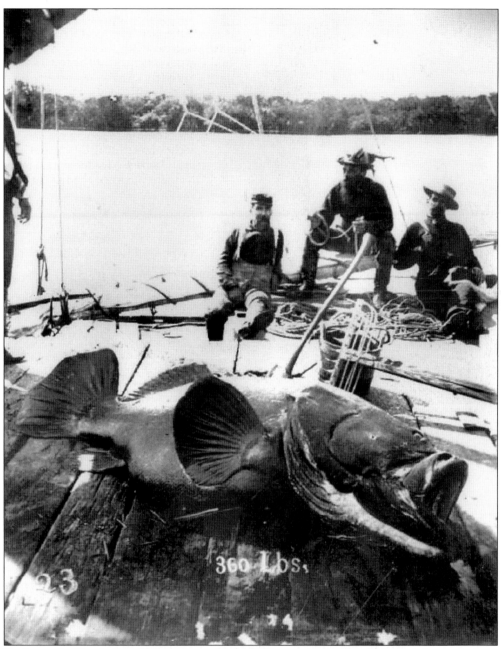

Dr. James A. Henshall and his party caught this 360-pound jewelfish off the lighthouse dock on a visit to Jupiter in 1884. In his guide *Camping and Cruising in Florida*, he wrote that Captain Armour was a courageous and resourceful man. (Courtesy of Florida State Archives.)

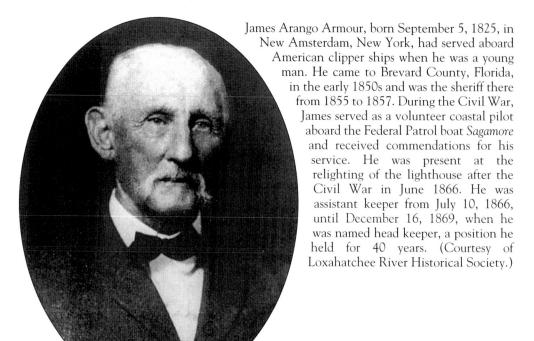

James Arango Armour, born September 5, 1825, in New Amsterdam, New York, had served aboard American clipper ships when he was a young man. He came to Brevard County, Florida, in the early 1850s and was the sheriff there from 1855 to 1857. During the Civil War, James served as a volunteer coastal pilot aboard the Federal Patrol boat *Sagamore* and received commendations for his service. He was present at the relighting of the lighthouse after the Civil War in June 1866. He was assistant keeper from July 10, 1866, until December 16, 1869, when he was named head keeper, a position he held for 40 years. (Courtesy of Loxahatchee River Historical Society.)

Bertha Armour Knight Bush, the youngest child of Captain and Mrs. Armour, remembers when Noah Agee was buried in the lighthouse lime grove that is located near the marked graves of the Wells and Erickson children. Noah's son, Edward Monroe Agee, worked as an assistant keeper at the time. Noah Agee died on February 23, 1892. Bertha married her first husband, Theodore Eugene "Cap" Knight, at the lighthouse in 1900; she was 15 years old. Cap's brother, Thomas Knight, was head keeper of Jupiter Lighthouse for six months in 1919 until he swapped jobs with Captain Seabrook and moved to the Hillsboro Light. This photograph was taken in 1954. (Courtesy of William Carlin White Collection.)

Charles Robert Carlin and his brother James came to this country from Ireland to work for the government. Charles applied for citizenship and was naturalized in 1860. He met Mary Moorer Joyner in Titusville, Florida, where they were married in 1868. In April 1871, they moved to Jupiter by sailboat. Charles held the position of assistant keeper under Capt. James A. Armour from April 1871 to May 1875, when he resigned and moved his family back to Titusville. (Courtesy of William Carlin White Collection.)

In May 1876, Melville Evans Spencer built a 16-foot cat rig sailboat and sailed alone down the Indian River from Titusville to Jupiter. The inlet was closed by sand when he arrived. He worked occasionally as a carpenter for Captain Armour, and when Armour's nephew left his position as assistant keeper, Melville was offered the job. He held this position from December 1878 until January 1884, when he transferred to Sombrero Key to be head keeper. As a photographer, he recorded many events in the local area including the views shown in these pages of the keeper's dwellings. (Courtesy of Spencer Family Collection. Self portrait by Melville E. Spencer.)

In June 1885, Captain Armour employed a young second assistant keeper named Dwight Adams Allen; he was fresh out of the navy and used to maneuvering the riggings of a naval ship. Dwight held that position until April 1886, when he was promoted to first assistant keeper, a position he held until December 1890, when he moved to the shores of Lake Worth. As entertainment was limited in those days, Dwight amused himself and others by walking on his hands around the railing of the lighthouse and walking around the edge of the roof. When he felt he had a sufficient audience of young ladies to warrant further antics, he did handstands on top of the parapet. (Photo Courtesy of Pam Allen Lock.)

David K. Harrison held the position of second assistant keeper under his uncle, Capt. James A. Armour, from April 1877 until May 1878, when he was promoted to first assistant keeper. He held this position until April 1879, when he resigned and went back to Brevard County. His mother Jane Carlile Harrison was the sister of Almeda Catherine Carlile Armour, wife of Captain Armour. (Courtesy of "Keepers of Florida Lighthouses" by Neil E. Hurley.)

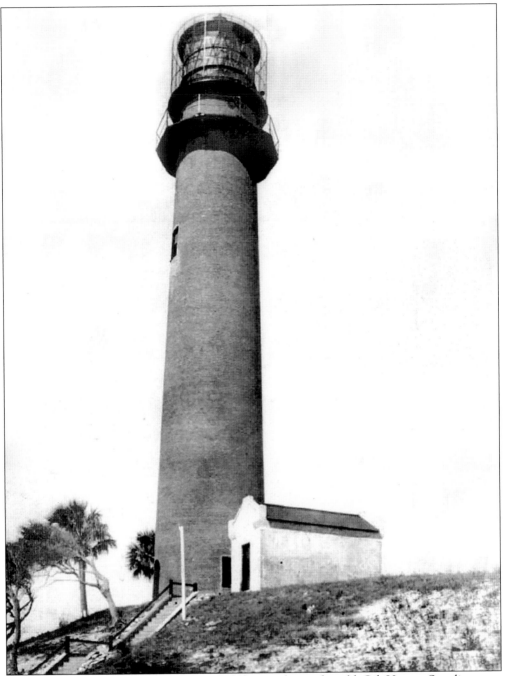

This 1895 photograph of the Jupiter Lighthouse shows the old Oil House. Supplies were shipped to construct the brick Oil House next to the tower in January 1860. The Oil House was built to store oil, lard, and other supplies needed to maintain and run the light. It was rebuilt in 1905. In this photograph, the lighthouse was not yet painted and the different layers of brick are evident. The cage around the lens was to keep ducks and other migrating birds from flying into the lenses, which they did almost nightly during the migrating season. (Courtesy of Florida State Archives.)

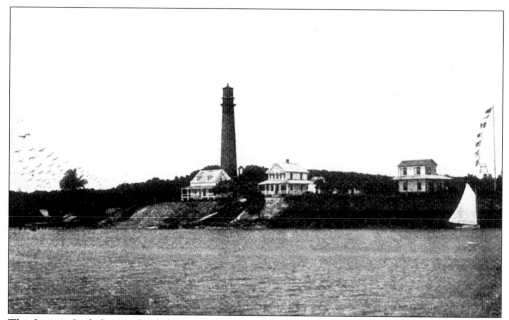

The Jupiter Lighthouse, both keeper's dwellings, and the two-story Weather Bureau with its signal flagpole are shown in this postcard. The United States Weather Bureau Station was established in 1889. At that time it was the southernmost weather station reporting activity on the east coast of the United States. It later moved to Miami. The signal flags can be seen flying in the right foreground. (Courtesy of Lynn Drake Collection.)

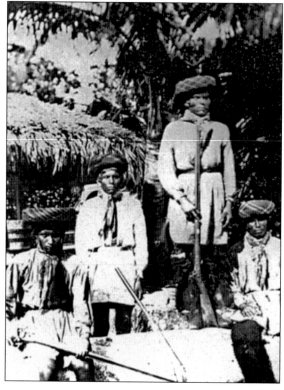

Melville Spencer photographed these visiting Seminoles at Jupiter Lighthouse in 1879. From left to right are Doctor's Boy, unknown, Robert Osceola, and Little Tyger. (Courtesy of Spencer Family Collection.)

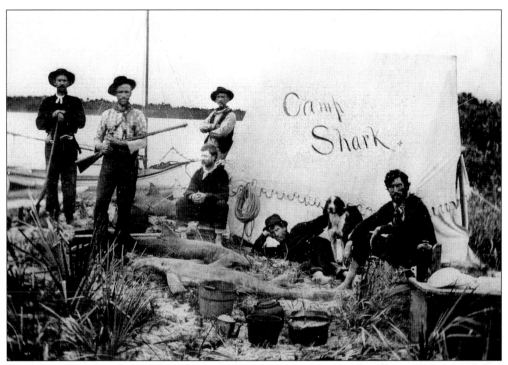

These men seem to be on a shark-shooting mission at "Camp Shark" on the Jupiter Inlet. (Courtesy of Loxahatchee River Historical Society.)

Charles Carlile Armour was born on February 15, 1879, in Jupiter to Capt. James and Almeda Carlile Armour. He was about 21 years of age when this photo was taken. Charlie worked as a convict guard in 1910 and later as a bridge tender. In 1929, Charlie sailed a boat down the East Coast Line Canal, now known as the Intracoastal Waterway, to Miami. Considered an extremely safe pilot, he became ill and was removed to his sister's home in Miami. He died there at the age of 40 from an illness of less than one week. He was brought back to Jupiter by train and his was the last funeral procession by water to the little Jupiter Cemetery. (Courtesy of William Carlin White Collection.)

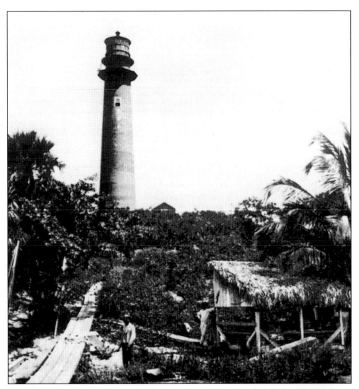

Capt. James A. Armour is shown leaning against a shack with an unknown man near the dock around 1885. (Courtesy of Loxahatchee River Historical Society. Photo by Melville Spencer.)

A close-up of the same view shows Captain Armour and one of his daughters with wash tubs under the shack. (Courtesy of Loxahatchee River Historical Society. Photo by Melville Spencer.)

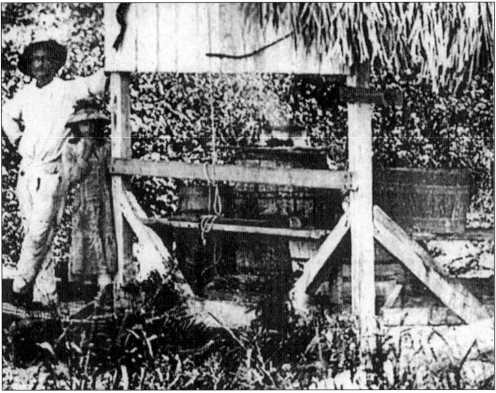

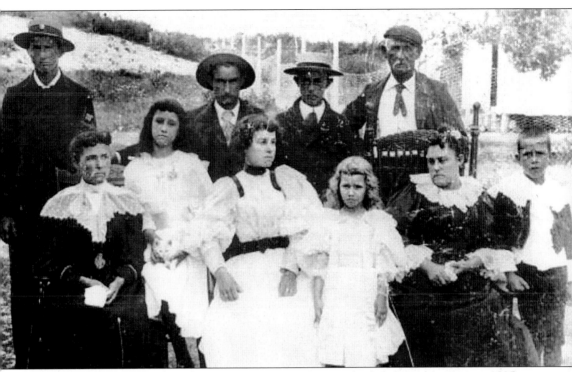

The Armour family is presented in a group portrait taken on the lighthouse property, c. 1895. The following are pictured from left to right: (front row) Almeda Carlile Armour (wife of Captain Armour), Bertha Lydia Armour, Katherine Dickerson "Kate" Armour (the first white child born in the area), Annie Armour Johnson, Lyda Thurston Armour Johnson, and Herbert Robert Johnson; (back row) James A. Armour Jr., Charles Carlile Armour, William Bryson Armour, and Capt. James Arango Armour.

Almeda Carlile Armour was the daughter of David Nathaniel and Eliza Carlile. David and Eliza came from South Carolina to Jones County, Mississippi, then on to Florida in January of 1854. Several of her brothers and nephews worked as assistant keepers of Jupiter Lighthouse through the years.

The Armours' third child, Mary Elizabeth Armour, was born sometime between 1872 and 1877. She died at the age of two and a half after having convulsions. James and Almeda had loaded a sailboat with sand so they could light a fire to heat water. They alternately bathed little Mary in hot and cold water all the way to the nearest doctor in Titusville, but she died anyway.

James Armour Jr. was a member of the Jupiter Lifesaving Crew for a short time and a fireman on the Celestial Railroad. He died sometime between 1897 and 1905.

Lyda Armour, born in 1871 in Jones County, Mississippi, married Dave Johnson of Cocoa Beach in 1888. They had two children, Herbert Robert and Annie Armour Johnson. (Courtesy of Loxahatchee River Historical Society.)

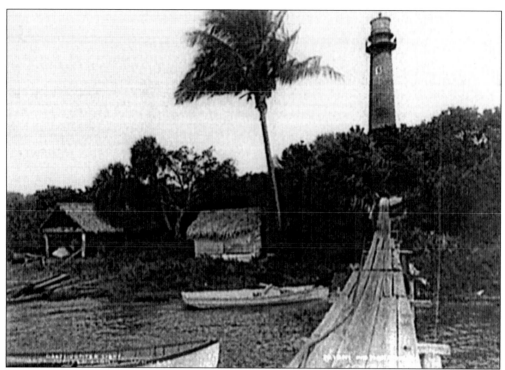

This photograph of the Jupiter Lighthouse, taken by William Henry Jackson around 1890, shows a small thatched shack, dock, boats, and what looks like a boathouse. The keeper's children were schooled in a small shack on the lighthouse property. (Courtesy of William Carlin White Collection.)

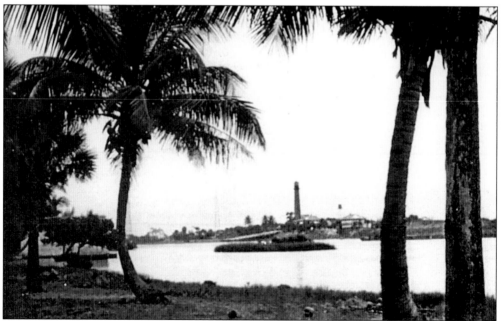

This 1910 view from the Carlin property includes the Jupiter Lighthouse and the Sperry Boathouse on the left side of the photograph. (Courtesy of William Carlin White Collection.)

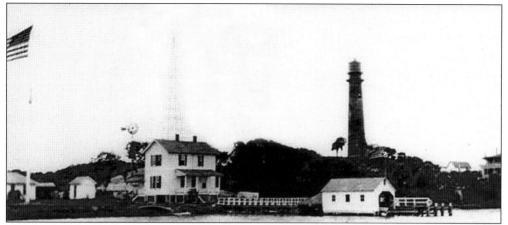

This 1900 view shows the Jupiter Wireless Telegraph Station complex. It was located on the north shore of the Jupiter River, west of the lighthouse on the southwest corner of the Jupiter Government Reservation property. It occupied about three acres—more or less of the reserved land—and its most obvious visible feature has been the antenna structures that varied over the years from simple wooden masts to massive steel towers; all of which have now been removed. The date when the Jupiter Wireless activity first became installed on the reservation is not very clear. It is believed that wireless equipment installation was started around 1890 and completed soon thereafter.

Somewhere around the year 1870, long before the "wireless" era, the Jupiter site was an important telegraph communications terminal and was operated by U.S. Navy personnel. This terminal was connected to Jacksonville, Florida, via a telegraph wire-line constructed by the Army Signal Corps some month earlier. In those early days the telegraph was used primarily to send and receive all kinds of information from northern "*wire designations*" through Jacksonville, and for many years it was the only rapid link that the government or the people in this part of the country had with the outside world. (Courtesy of William Carlin White Collection.)

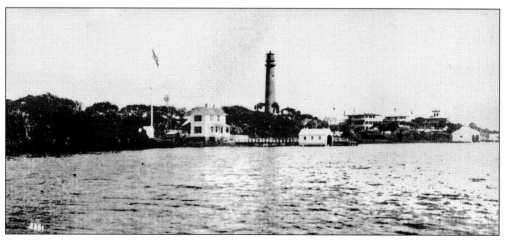

Another view taken in 1900 shows the Wireless Telegraph Station, keepers' houses, and the Weather Bureau. (Courtesy of William Carlin White Collection.)

Carl Olaf Svendsen was born on January 22, 1878, in the harbor of Cardiff, Wales, on board his father's ship, a Norwegian bark. He was only 18 years of age when he entered the lighthouse service and worked in the service continuously for 38 years. The first three years were served on Frying Pan and relief light ships. From there he was transferred to Bulls Bay Light Station, South Carolina, as assistant keeper, then to Jupiter Light Station. Mr. Svendsen held the position of second assistant keeper under Capt. James A. Armour from April 21, 1901, to January 1, 1903. Mr. Svendsen married Annie Demarius Baker at the Jupiter Light Station on February 5, 1902. Annie was the daughter of Thaddeus and Wealthy Bennett Baker of Charleston, South Carolina. Thaddeus Baker moved his family to Jupiter in the late 1890s and later sold his home to Samuel Barfield. He then went to Charleston Light Station, South Carolina, and on May 27, 1907, assumed charge of St. Simons Light Station as keeper until his death in 1934. (Courtesy of Loxahatchee River Historical Society.)

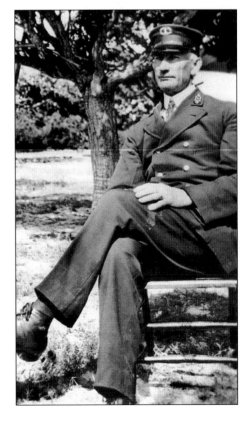

Joseph A. Wells, born in Indiana in January 1864, was first assistant keeper of Jupiter Lighthouse under Capt. James A. Armour from October 22, 1894, until September 16, 1906, when he was promoted to keeper. His father-in-law, James Armour, retired after 40 years of service. Captain Wells retired on April 30, 1919. Joe married Kate Armour Roberts, daughter of Capt. James and Almeda Armour, in March 1898. Joe and Kate had two stillborn infants, who are buried on the lighthouse property in a small cemetery along with two-year-old Richard Ericksson, the son of assistant keeper John E. Ericksson and his wife Maggie. Richard had died of lockjaw in September 1906. (Courtesy of Loxahatchee River Historical Society.)

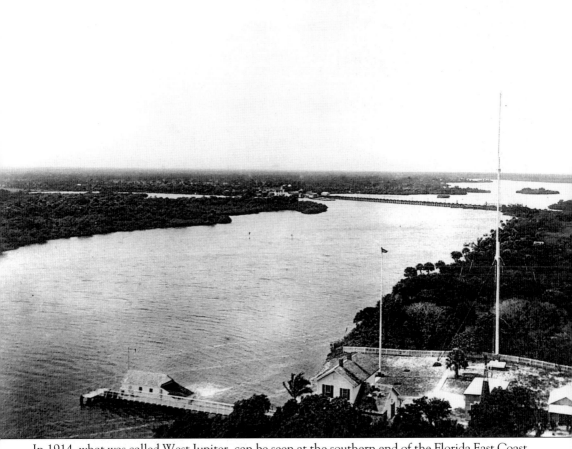

In 1914, what was called West Jupiter, can be seen at the southern end of the Florida East Coast Railroad Bridge. The entire area was called Jupiter until 1894 when Henry Flagler brought his Florida East Coast Railroad south through Jupiter to West Palm Beach. Prior to 1894, there were no bridges to connect the different areas on either side of the river. Travel was done by way of the water and all manner of sea craft could be found in the river: steamboats, sailboats, rowboats, and more.

Flagler's railroad put an end to the usefulness of the Celestial Railroad. This little railroad was built to provide transportation overland about eight miles south where travel could commence by water on Lake Worth. Many settlers moved their businesses and homes to the west side of the river to have access to the railroad. To avoid confusion, this area was called West Jupiter. This view from the top of Jupiter Lighthouse also overlooks the Jupiter Wireless Telegraph Station and its antennas, dock, and outbuildings. (Courtesy of William Carlin White Collection.)

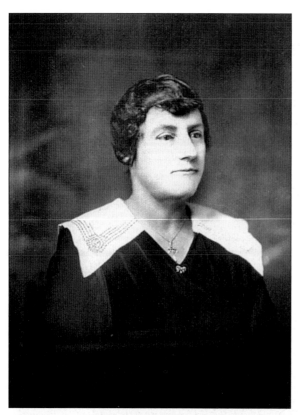

Katherine Dickerson Armour, born in November 1868, was the first child of Almeda Carlile and James A. Armour and the first white child born in this area. Her sister, Bertha Armour Knight Bush, recalled how a Seminole brave wanted Kate for his squaw. Kate would run and hide whenever she saw the Native Americans coming to visit the lighthouse. She married John S. Roberts in 1887 and first assistant keeper Joseph Wells in 1898. This portrait of Kate was taken around 1900. (Courtesy of Loxahatchee River Historical Society.)

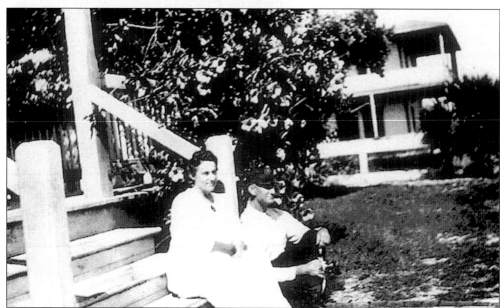

Joseph and Kate Wells relax on the steps of their home about 1915. They married on March 14, 1898. Joe had been first assistant keeper of the Jupiter Lighthouse under Kate's father Capt. James A. Armour since October 1894. He was promoted to keeper in September 1906 and retired in April 1919. (Courtesy of Loxahatchee River Historical Society.)

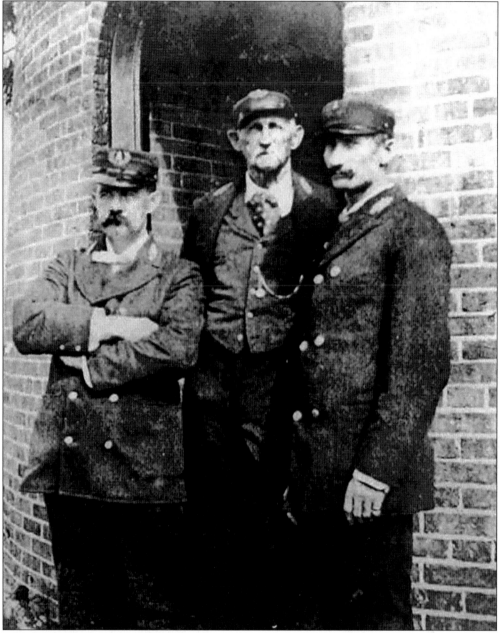
Captain Armour and two assistant keepers pose in front of the lighthouse door prior to 1906. Armour is the gentleman in center. (Courtesy of Loxahatchee River Historical Society.)

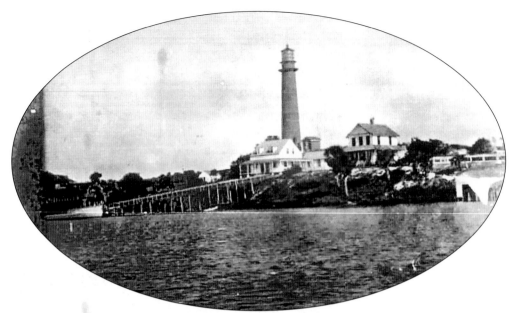

Looking northwesterly, the two keeper's homes had not yet been renovated with wraparound porches when this photograph was taken about 1905. (Courtesy of Loxahatchee River Historical Society.)

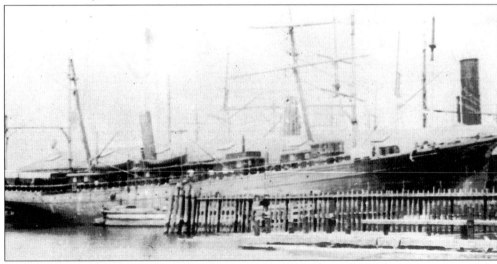

In *Shipwrecks in the Vicinity of Jupiter Inlet*, Bessie DuBois relates that "The Victor, one of the Mallory line vessels in the coastal trade, went down a few hundred yards offshore south of Jupiter Inlet in 1872. On October 20th, the Victor broke a shaft in a roaring northeaster off Jupiter and at first was anchored. When it seen there was no hope of stopping the water pouring into the ship, it was allowed to drift ashore. The keepers of Jupiter Lighthouse, Captain James Armour and his assistants, Carlin and Pierce, saw the Coston light and went to the aid of the distressed vessel. The Pierce family salvaged a sewing machine, and three prize dogs, collies named Vic, Storm and Wreck, swam ashore and became members of the lighthouse families. Clothing, yard goods and cases of hardware floated into the river and up on the beach. Seven canoe loads of Indians appeared from the Everglades and joyfully participated in the salvage, camping on the beach." (Courtesy of Florida State Archives.)

Capt. Joseph A. Wells and a man thought to be Frank Skill visit in the top of the Jupiter Lighthouse about 1911. (Courtesy of Frank Gentner Collection.)

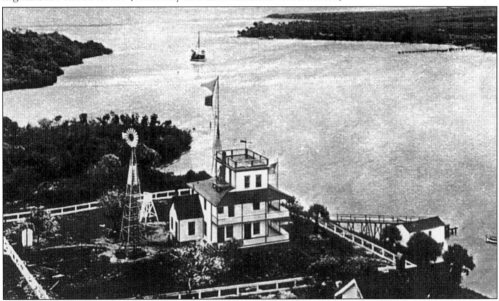

The United States Weather Bureau, Jupiter Inlet, DuBois Home, and Carlin House dock can be seen on this 1910 postcard. The United States Weather Bureau had added a third-floor, railed-promenade deck above where some of the weather instruments were kept and read daily. If a ship was observed passing within view and was recognized by its signal flag display, the weather personnel, in the spirit of mutual cooperation, would routinely copy the message. Later, any messages, along with daily weather data, would be taken to the Navy Wireless Telegraph office for delivery to Jacksonville. (Courtesy of Lynn Drake Collection.)

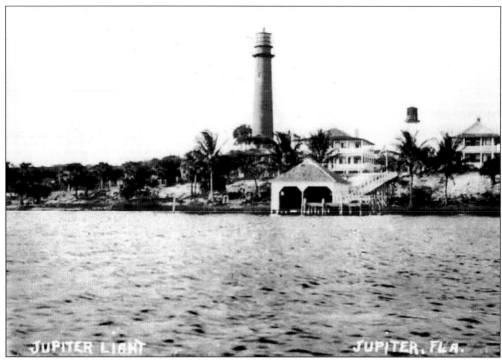

In this 1910 northwesterly view, the two keeper's homes have had wraparound porches added to each floor. The postcard was compliments of the Wayside Inn. (Courtesy of Lynn Drake Collection.)

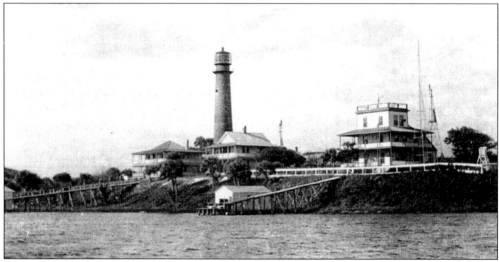

This 1912 photograph taken by the Willoughby family shows a different perspective of the Jupiter Lighthouse complex. (Courtesy of Martin County Historical Society.)

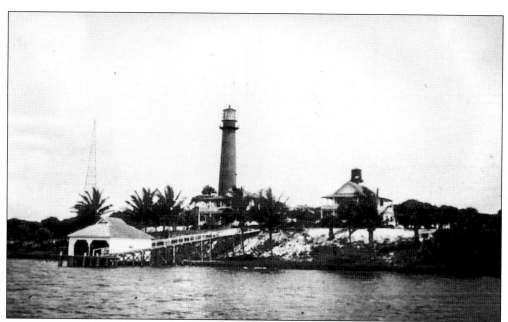

This photograph, taken about 1915, shows the two keeper's dwellings and a boathouse on the Jupiter Lighthouse property. The tower to the left was a modern support antenna for the Wireless Telegraph Station. (Courtesy of Loxahatchee River Historical Society.)

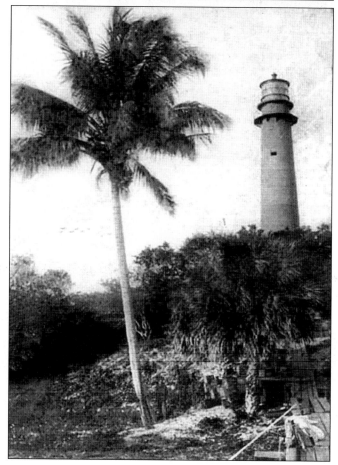

Seth Shear, Indian River Photographer, took this photograph of Jupiter Lighthouse in the 1890s. Shear traveled the paddle wheel steamers up and down the Indian River from Titusville to Jupiter, photographing the scenery as well as the steamers and their captains. (Courtesy of Skip Gladwin Collection.)

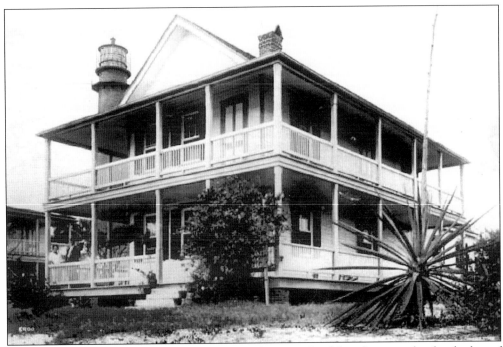

Capt. Joe Wells and his wife Kate are shown on the veranda of their home under the shadow of Jupiter Lighthouse around 1915. He retired in 1919 and they moved to West Palm Beach. Joe died on October 6, 1930, and Kate on September 19, 1936. They are buried in Woodlawn Cemetery in West Palm Beach. (Courtesy of Loxahatchee River Historical Society.)

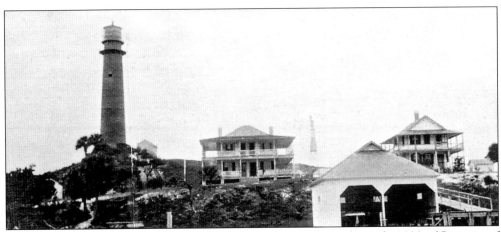

This view of the keeper's dwellings and boathouse was taken in the early 1920s. (Courtesy of Loxahatchee River Historical Society.)

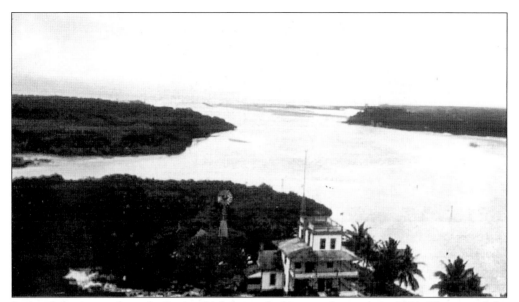

Jupiter Inlet is seen from the Jupiter Lighthouse looking southeasterly in 1924. The area of the inlet changed continually through the years, sometimes closing for years at a time. This changed with the construction of a jetty in the 1920s. (Courtesy of Loxahatchee River Historical Society.)

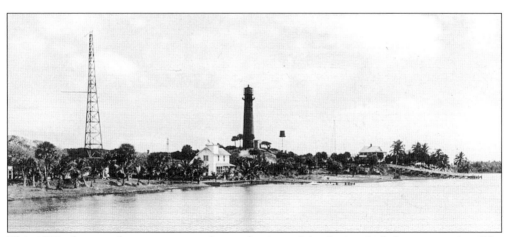

This 1929 photograph presents a northeasterly view of the Jupiter Lighthouse complex. The modern support antenna for the Wireless Telegraph Station was erected after the 1928 hurricane. It was blown down by a tornado during a fierce storm sometime before World War II. The U.S. Wireless Telegraph Station can be seen between the tower and the Lighthouse. (Courtesy of Loxahatchee River Historical Society.)

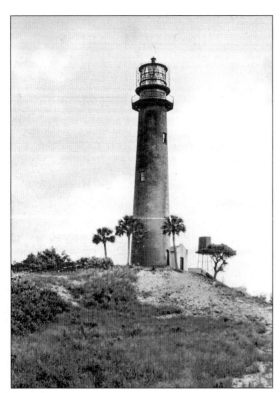

This 1930 postcard view of Jupiter Lighthouse shows the oil house and water tower. The postcard was compliments of Shuey's Inn and Restaurant on U.S. Highway 1 just west of the lighthouse. (Courtesy of Lynn Drake Collection.)

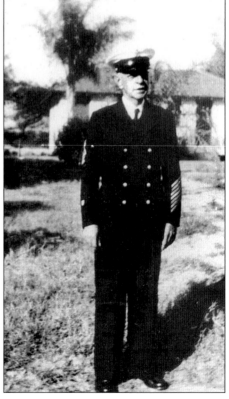

Capt. Franklin Charles Seabrook, born in Hardeeville, South Carolina, in November 1883, was first a keeper of the Tybee Island Lighthouse in Georgia. He worked for the Hillsboro Light in Florida for a short time until he exchanged posts with Capt. Thomas Knight of the Jupiter Lighthouse and assumed duties under the United States Department of Commerce in 1919. He married Dora Weiking near Charleston, South Carolina, about 1910. Their fourth child and second daughter Dorothy was born in Jupiter in 1920. This photograph of Capt. Seabrook was taken in the 1930s. He retired in August 1946 and died in Coral Gables in February 1952. (Courtesy of Loxahatchee River Historical Society.)

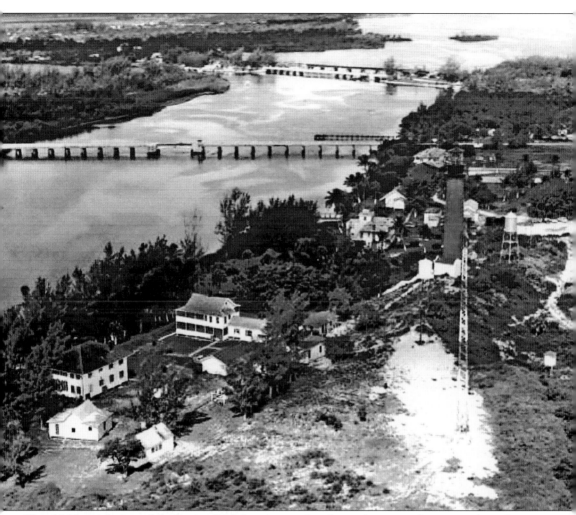

This 1946 aerial view of the Jupiter Lighthouse complex shows the many changes made at the start of World War II. Older buildings were upgraded and new ones erected to house the Naval Intelligence personnel and the families attached to the radio station. One of the only buildings left standing today is what is known as the old barracks building. In the photograph, it is the large white building located on the left side of the top of the lighthouse. This particular building was constructed in 1939 as the Chief Petty Officer Marriage Quarters. At present, the Loxahatchee River Historical Society uses a portion of the first floor for its Jupiter Lighthouse Visitor's Center and Gift Store. Visitors may climb the 105 steps to the top of Jupiter Lighthouse, which is listed on the National Register of Historic Places. The Loxahatchee River Historical Society, formed in 1971 as a non-profit organization in Jupiter, is a unique cultural and educational institution that operates the DuBois Pioneer Home, Jupiter Inlet Lighthouse, and the Loxahatchee River Historical Museum. In the right foreground in the clearing, the original long wave navigational beacon (.J.) can be seen. (Courtesy of William Carlin White Collection.)

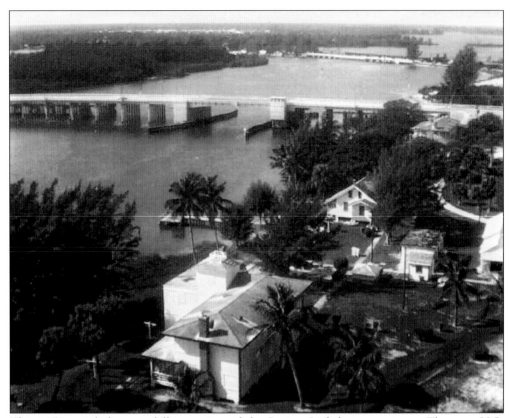

This 1950 aerial shows a different view of the Jupiter Lighthouse property. The new U.S. Highway 1 bridge has been built, leaving portions of the original on either side of the river for fishing. (Courtesy of Florida State Archives.)

Barden's Boating Center and the new southbound U.S. Highway 1 can be seen from the lighthouse in this 1955 photograph. (Courtesy of Florida State Archives.)

Two

U.S. Lifesaving Station

According to Elsie Dolby Jackson's Early History of Jupiter, on April 1, 1885, "by the President's order, Lots 4 and 5, section 5, township 41 south, range 43 east were reserved for lifesaving purposes." The Jupiter Lifesaving Station was opened in 1886 and Capt. Charles Carlin was appointed to organize it. At most of the stations on the Atlantic coast, the station crew included six to eight surfmen, with an additional man during the winter months. The surfmen were re-enlisted from year to year, subject to physical examination. The stations were fully manned from August 1 to May 1, and manned only by the keeper of the Lifesaving Station during the summer months. Many of these men also held positions as assistant lighthouse keepers.

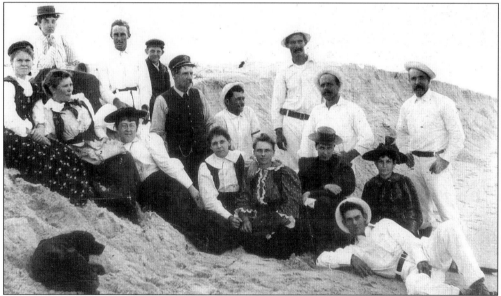

This photo, taken about 1895, shows the Jupiter Lifesaving Crew and their families celebrating the arrival of their first self-bailing whaleboat. Pictured from left to right are (front row) Leah King, Ola Kyle Grant (wife of John Grant), Nora Magill King (wife of Edward B. "Ned" King), Tag Kyle, Eliza Kyle Cabot (wife of Fred Cabot), Lyda McConnell, Ella Carlin Aicher (wife of Conn Aicher), Charlie Carlin, and the Lifesaving Station dog in the left foreground; (back row) Anna "Nan" McConnell Magill (wife of Fred Magill), Graham W. King Sr., Fred M. Cabot II, Capt. Charles R. Carlin, Dan Ross, Harry DuBois, Tom Mitchell, and John H. Grant. (Courtesy of William Carlin White Collection.)

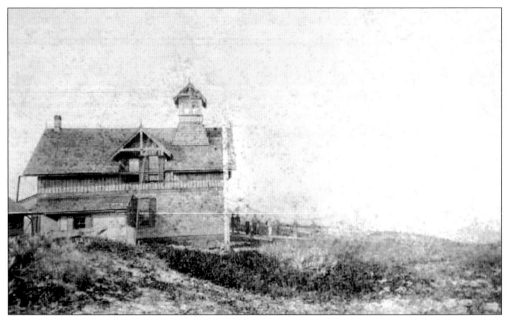

This building was home to the Jupiter Lifesaving Station from 1886 to 1896. The Jupiter Lifesaving Crew stands on the ramp with their lifeboat. The station was known to be the picture of cleanliness and much pride went into this chore. The men and their families were very close and pictures of their gatherings show a happy and diverse group. These men worked hard and were diligent in their drills and training. (Courtesy of William Carlin White Collection.)

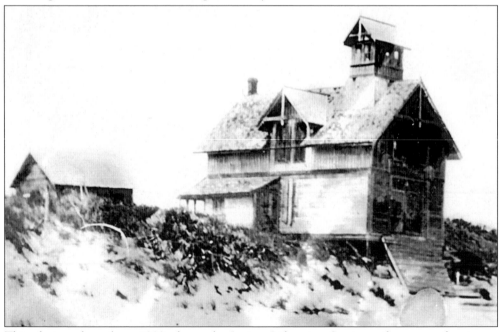

This photo, taken about 1900, shows the Jupiter Lifesaving Station a few years after it was abandoned. Although there were never any serious wrecks, numerous lives and vessels were saved. Many were given material aid and a place to stay until they were able to continue their travels. (Courtesy of William Carlin White Collection.)

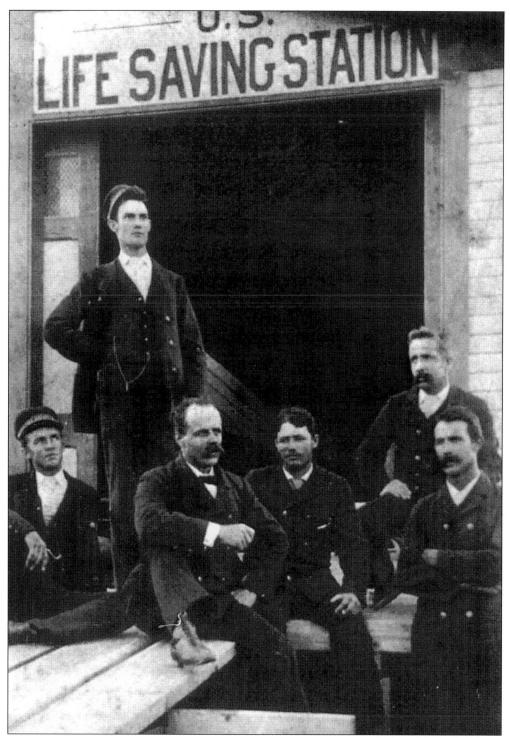

The proud crew of the Jupiter Lifesaving Station, *c.* 1887, from left to right, are Graham King, young Charles W. Carlin (standing), John Grant, Daniel Ross, Tom Mitchell (sitting against the right side of the opening), and Harry DuBois. (Photo Courtesy of Florida State Archives.)

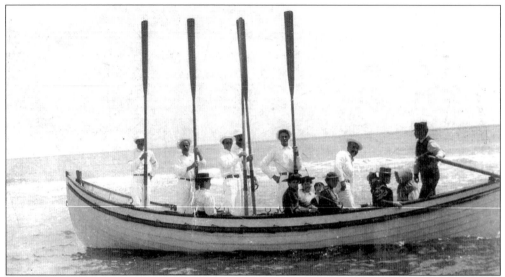

The Jupiter Lifesaving Crew and their families celebrate the arrival of this self-bailing lifeboat in 1895. Pictured from left to right are (front row) Anna "Nan" McConnell Magill, Ella Carlin Aicher, Nora Magill King, Leah King, Eliza Kyle Cabot, Tag Kyle, Lyda McConnell, and Ola Kyle Grant; (back row) Daniel Ross, Tom Mitchell, Graham W. King Sr., Harry DuBois, Charlie Carlin, John Grant, and Capt. Charles R. Carlin. (Courtesy of William Carlin White Collection.)

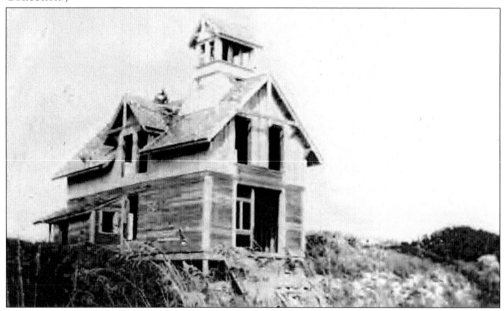

This photo, taken about 1912, shows the Jupiter Lifesaving Station long after it had been abandoned. The station was closed after the winter of 1896 when Flagler's new Florida East Coast Railroad made travel by water almost obsolete. The government abandoned the service because there was no longer a need for the Lifesaving Station with so little ocean traffic. Captain Carlin remained faithful in keeping the station and apparatus until the government removed it. The building was sold to Carlin's son-in-law, Graham King Sr., who in turn sold it to Harry DuBois. (Courtesy of William Carlin White Collection.)

Three
CARLIN HOUSE

The Carlin House, built in 1886, would be the oldest residence in Jupiter had it survived. Transportation, such as it was at that time, ended at the Jupiter River and the Carlins were forced to accommodate worn out travelers any way they could long before they were prepared. Over the years, Grandma Carlin said, many times, that in the beginning she really never knew who or how many would show up for breakfast.

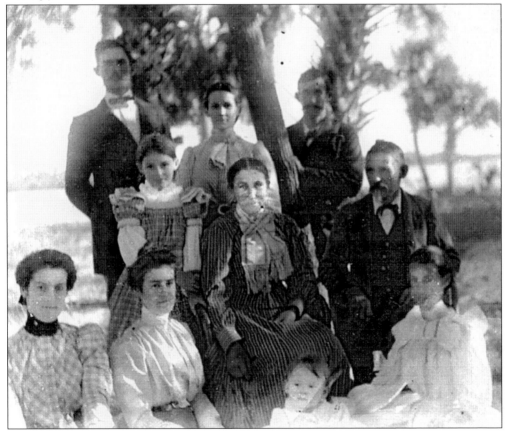

This 1898 Carlin family portrait was taken in the front yard with Jupiter Island in the background. Pictured from left to right are (front row) Edith Lyons Carlin, Mary Nauman Carlin, Harry Aicher, and Susan P. Carlin; (middle row) Emily B. Carlin, Mary Joyner Carlin, and Capt. Charles Robert Carlin; (back row) Charles Wesley Carlin, Ella May Carlin Aicher, and James Henry Carlin. (Courtesy of William Carlin White Collection.)

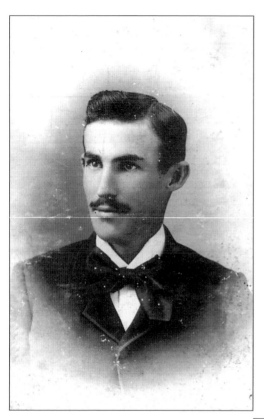

Capt. Charles R. Carlin, shown here as a young man, was an accomplished sailor having spent his entire life as a seafaring man, first in the British Navy and then with the Geodetic Surveyors. He came to this country to work for the government and was naturalized in 1860. He met Mary Moorer Joyner in Titusville, Brevard County, Florida. They were married in 1868 and in April 1871, they moved to Jupiter by sailboat. Charles held the position of assistant keeper under Captain Armour from April 1871 to May 1875, when he resigned. In 1875, the Carlin family returned to Titusville, where Charles owned C.R. Carlin Boatworks in Joynerville and got a job with the United States Geological Survey group. In 1886, the Carlin family moved back to Jupiter and Captain Carlin took command of the newly organized Jupiter Life Saving Station. Capt. Charles Carlin died on October 12, 1912, of injuries suffered when he fell from the roof while trying to prevent a brush fire from reaching the abandoned lifesaving station of which he was still caretaker. (Courtesy of William Carlin White Collection.)

This 1865 photograph of Mary Moorer Joyner, age 15, was taken in Titusville, Florida. She was born to Rachael Rast and John Wesley Joyner near Charleston, South Carolina. The family moved to Sandpoint, Volusia County, Florida, around 1860. Sandpoint was renamed Titusville by Henry Titus and the Brevard County lines moved north to include this area. By the age of 15, Mary owned property that she platted and named Joynerville. Capt. Carlin took Mary back to Titusville by boat for the delivery of each of their first six children, to ensure she would be under a doctor's care. Their youngest daughter Emily, born in May 1889, was the only child born in the Carlin House. (Courtesy of William Carlin White Collection.)

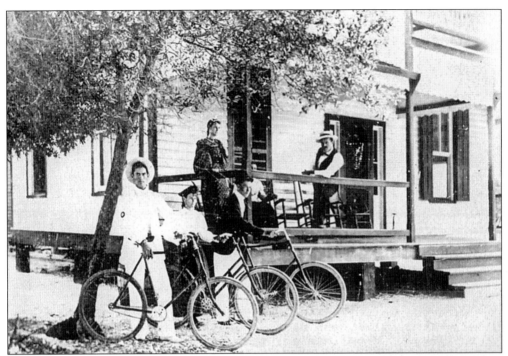

Mary Moorer Joyner Carlin, wife of Capt. Charles R. Carlin, enjoys an afternoon on the porch with her children and brother. This picture shows the northeast corner of the original Carlin House, looking southeast in 1887. On the porch, from left to right, are Ella Carlin, Mary Carlin, and Henry Carlin. On the bicycles, from left to right, are Charlie Carlin, Nauman Carlin, and Will Joyner, half brother to Mary Joyner Carlin. (Courtesy of William Carlin White Collection.)

Mary Nauman Carlin, born in January 1881, never married. In the beginning, the operation of the Carlin house as a hotel and restaurant was shared by all the Carlin women. When the three older sisters married and left home, Aunt Nauman took charge of everything. Although all the cooking was done by Grandma Carlin and the servants, menu planning, the ordering of supplies, and bookkeeping was the responsibility of Aunt Nauman. William Woolworth and William Thayer advised her on financial investments, William Sperry taught her the value of professionalism, and Robert Dixon advised her on providing recreation for the guests. Nauman died in 1921 at the age of 40. (Courtesy of William Carlin White Collection.)

Harry Aicher, child of Ella Carlin and Dr. Ferdinand Constantine "Conn" Aicher, was born in August 1898 in Minnesota. He is shown here with his Grandmother Aicher the same year. Conn Aicher came from Bristol, England, and was naturalized in 1882. He married Ella May Carlin in November 1897. Conn owned a general store called F.C. Aicher & Co. in Jupiter. (Courtesy of William Carlin White Collection.)

Harry Aicher strikes quite the pose in this 1898 photo. He was the first grandchild of Capt. Charles R. and Mary Joyner Carlin. (Courtesy of William Carlin White Collection.)

Harry Aicher is pictured at the Carlin House with his fishing pole about 1910. He eventually became Jupiter's postmaster, a position he held for many years. The terminus of the Indian River can be seen in left background. (Courtesy of William Carlin White Collection.)

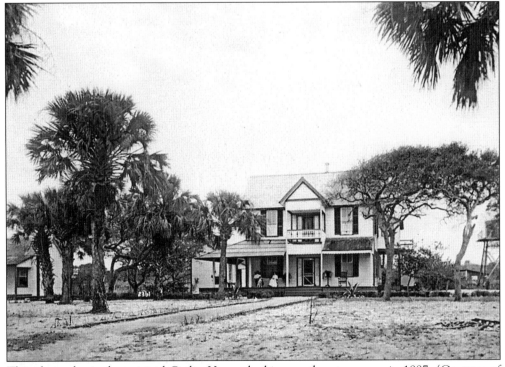

This photo shows the original Carlin House, looking southeast, as seen in 1887. (Courtesy of William Carlin White Collection.)

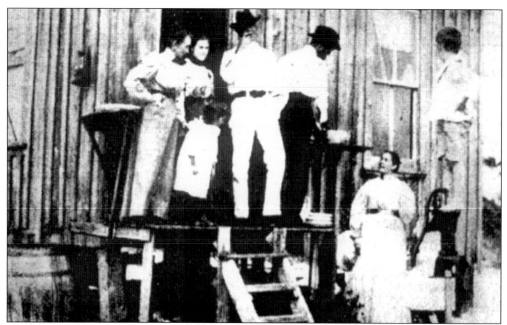

Family and friends enjoy a picnic at Will Joyner's cottage in Jupiter near the Celestial Railroad complex in 1898. Pictured, from left to right, are two unknown women and an unknown child; Charlie Carlin; Harry DuBois, looking at Susan Sanders, who became his wife that same year; a young girl next to Susan; and a boy on the water pump. (Courtesy of William Carlin White Collection.)

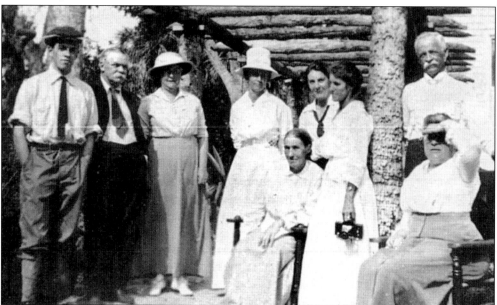

The west porch of the Carlin House is shown in this 1900 photograph. The bougainvillea arbor, or pergola, leads to the west cottage. The following are pictured from left to right: (sitting) Grandma Carlin and Nora Magill King, wife of Ned King; (standing) Gardner Dumas, Mr. Ernest Gardner Dumas, Seraphine Dumas, Ella Carlin Aicher, Emily Carlin, Nauman Carlin, and Edward B. "Ned" King. (Courtesy of William Carlin White Collection.)

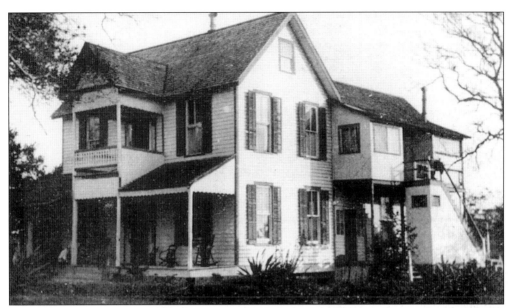

This 1890 photograph of the Carlin House shows its first modifications—a two-story addition on the south side, a bathroom on top of the outdoor stairs, and another on the first floor underneath. The Carlin House was in existence for almost 75 years. It reached its activity peak in the years between 1895 and 1930, gradually phasing out as a commercial hotel venture around 1939. (Courtesy of William Carlin White Collection.)

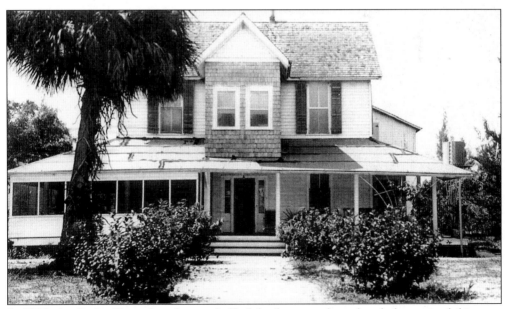

In 1900, the Carlin House has the east half of the front porch enclosed, decorative hibiscus, a water tower, and windmill, slightly visible. (Courtesy of William Carlin White Collection.)

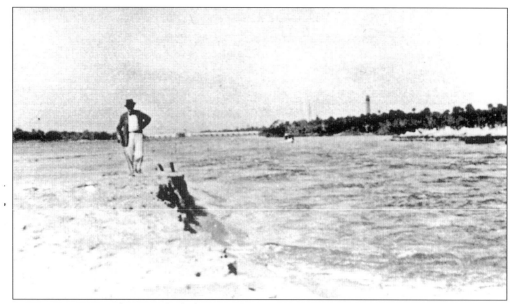

In 1926, Dr. Leonard C. Sanford observes the inlet washing itself open after being completely closed. When the inlet was closed and the river was abnormally high, the action could sometimes be spontaneous or would happen when someone started the process by digging a ditch across the sand barrier. (Courtesy of William Carlin White Collection.)

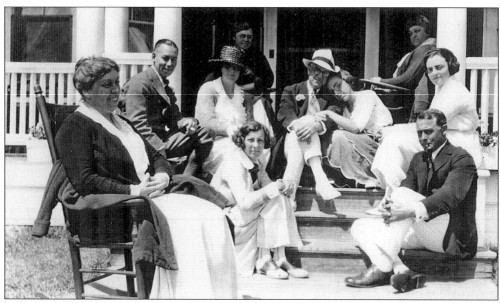

Nora Magill King, in the rocker, Dr. Meigs in the white hat, and his daughter next to him, are pictured with other, unidentified Carlin House guests. (Courtesy of William Carlin White Collection.)

Emily Carlin White is pictured with her son William Carlin White in 1908. Emily, born in Jupiter in May 1889, was the youngest child of Capt. Charles and Mary Carlin. When she became old enough, Nauman put her in charge of all needed repairs and modernization efforts. She married William Arthur White in July of 1906 and their only child Carlin was born in August 1907. (Courtesy of William Carlin White Collection.)

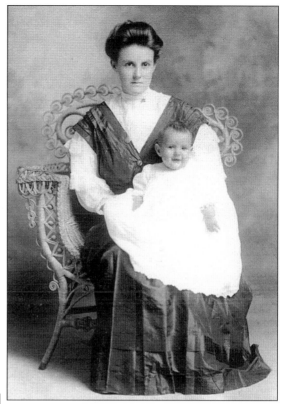

Susan Carlin is shown in her traveling outfit on the day she married Rex Albertson, November 17, 1909. Rex met Susan while he was stationed at the Jupiter Naval Radio Station. They moved to Seattle, Washington for 5 years and were convinced by the Carlin family to return to Jupiter, which they did in 1915. Rex bought Robert Jackson's machine shop and boathouse on the south end of the F.E.C. railroad bridge. He sold it and opened a service station on the northwest corner of Center Street and Old Dixie. Their daughter Mary Albertson married Dan T. Ryan in 1934. Rex died in 1946 and Susan in 1961. (Courtesy of William Carlin White Collection.)

Capt. Charles R. and Mary Carlin are pictured here. (Courtesy of William Carlin White Collection.)

A great visionary and scholar, John Cleminson was Jupiter's first school master, music teacher, mail carrier, and community leader. He served for a time as Dade County Commissioner. This photo was taken in 1900.(Courtesy of William Carlin White Collection.)

Mary Albertson is shown here under the pergola leading to Capt. Carlin's Boat Shop shown on the left. This photo was taken on the Carlin House property around 1917. (Courtesy of William Carlin White Collection.)

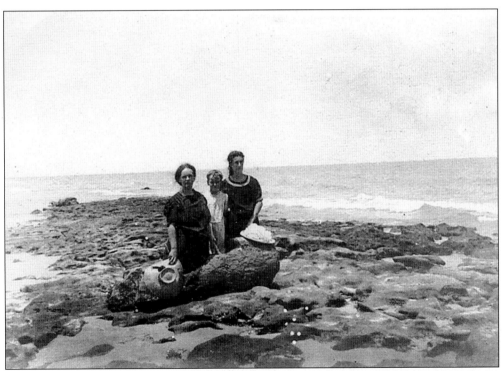

Addie Damon Carlin (wife of Charlie Carlin), Graham King Jr., and Edith Carlin King are pictured at the inlet beach in 1912. (Courtesy of William Carlin White Collection.)

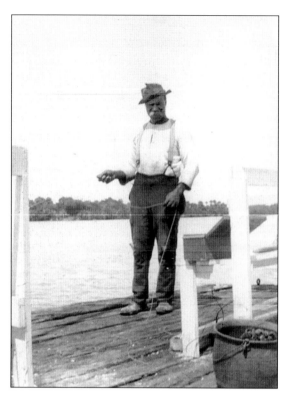

"Old Daddy" Adam Bryant is shown line fishing from the Carlin House dock. Notice the smudge pot to smoke away mosquitoes. Old Daddy, born a slave in 1850, became acquainted with Mary Joyner on her family's plantation near Charleston, South Carolina. The unusual strong bond of friendship, created when they were children, lasted throughout their lives. Adam Bryant ultimately followed Mary Joyner Carlin to Florida. He worked with the F.E.C. railroad section gangs near Titusville and later near Jupiter. After working at the Carlin House for many years, Old Daddy and his wife bought land near their old home in Thomasville, Georgia. He would leave Jupiter in April and return to work there in November. Adam Bryant died in 1944 and Grandma Carlin died later that same year. (Courtesy of William Carlin White Collection.)

Susan Carlin and Carlin White are shown about 1908. (Courtesy of William Carlin White Collection.)

Carlin White is pictured with his bear in 1908 at the Carlin House. (Courtesy of William Carlin White Collection.)

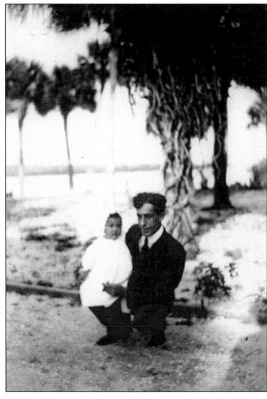

William Arthur White is pictured with his son, William Carlin White, at the Carlin House in 1908. (Courtesy of William Carlin White Collection.)

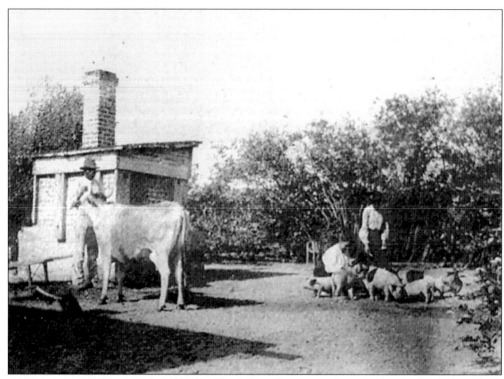

A man named Clarence and Old Daddy Adam Bryant work with the Carlin House farm animals. (Courtesy of William Carlin White Collection.)

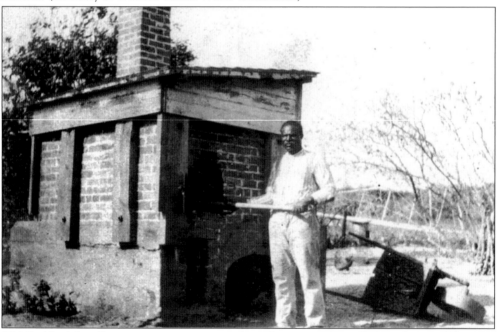

Old Daddy Adam Bryant was a young man when this picture was taken at the wood-burning brick oven on the south end of the Carlin House property. (Courtesy of William Carlin White Collection.)

Dora Carlin poses with her kitten and Poland Water bottle at the Carlin House. Poland Water was supplied as refreshment for the Carlin House guests. (Courtesy of William Carlin White Collection.)

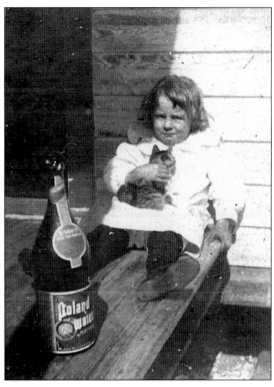

Carlin White shows off his sailor suit on the Carlin House dock. (Courtesy of William Carlin White Collection.)

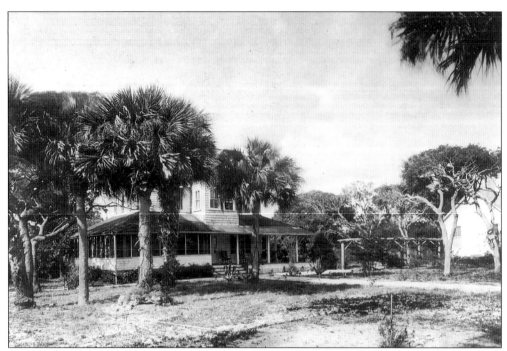

The Carlin House, with the west cottage on the right, is seen here in a southwest view. (Courtesy of William Carlin White Collection.)

The East Cottage is pictured in 1890, before the bath and dressing room were added to the back. (Courtesy of William Carlin White Collection.)

Carlin White plays in a Quaker Oats box at the Carlin House about 1908. (Courtesy of William Carlin White Collection.)

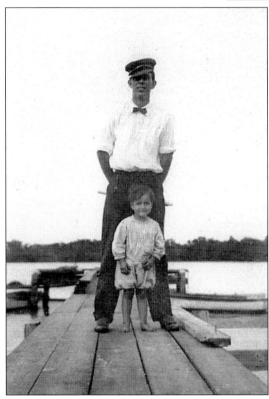

Carlin White and Charlie Armour pose on the Carlin House dock about 1910. (Courtesy of William Carlin White Collection.)

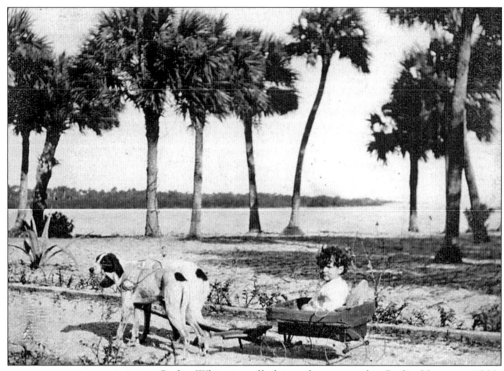

Carlin White is pulled in a dogcart at the Carlin House, *c.* 1909. (Courtesy of William Carlin White Collection.)

Carlin White is pictured around 1910. (Courtesy of William Carlin White Collection.)

Carlin White poses in a dark sailor outfit with the inlet in the background about 1912. (Courtesy of William Carlin White Collection.)

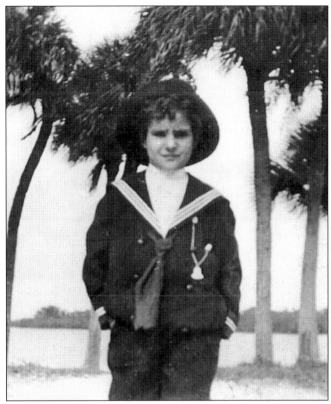

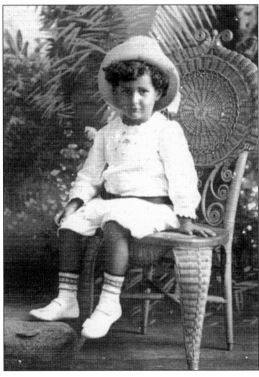

Carlin White is shown sitting in a wicker chair about 1911. (Courtesy of William Carlin White Collection.)

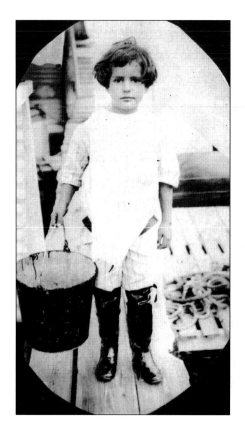

Carlin White stands on the Carlin House dock with his bucket and fishing boots, c. 1912. (Courtesy of William Carlin White Collection.)

Mary Byrnes Carlin, the second wife of Charlie Carlin, is pictured in 1920. (Courtesy of William Carlin White Collection.)

Nellie Mae Wells Carlin is shown here with her two children, Edith and Charles, in 1915. She married James Henry Carlin, eldest son of Capt. Charles and Mary Carlin, about 1905. Henry was a justice of the peace in the early 1890s, performing marriages in Dade County. He worked as first assistant keeper of the Ponce de Leon Inlet Lighthouse in Volusia County from September 5, 1899, to March 1, 1900. Henry then moved to Brunswick, Georgia, where in 1920 he was listed as keeper of the harbor, or range lights. In 1930 Brunswick, he was listed as light keeper and Nellie was teaching music. (Courtesy of William Carlin White Collection.)

These three men pictured on the Carlin House dock are believed to be important members of the infamous Ashley Gang (this according to Charles W. Carlin, a deputy sheriff who served under Palm Beach County Sheriff Bob Baker.) The Ashley Gang, led by John H. Ashley, gained fame in the early 1900s as an outlaw group who robbed banks, ships at sea, motorists, and passenger trains. They robbed the Stuart Bank twice but would not rob women. John Ashley, Hanford Mobley, Clarence Middleton, and Ray Lynn were shot to death on a bridge south of Sebastian, Florida, on November 1, 1924. (Courtesy of William Carlin White Collection.)

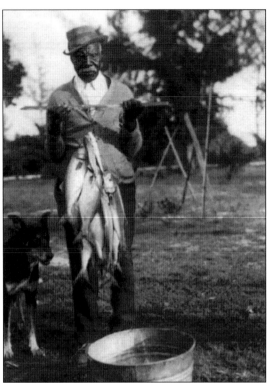

Old Daddy holds a mess of fish in December 1938. (Courtesy of William Carlin White Collection.)

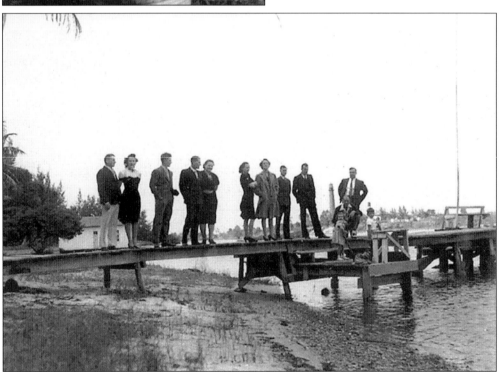

A holiday celebration is captured on the Carlin House Dock. (Courtesy of William Carlin White Collection.)

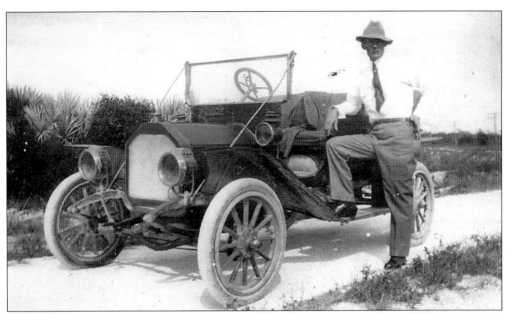

Charlie Carlin poses with his Cadillac. (Courtesy of William Carlin White Collection.)

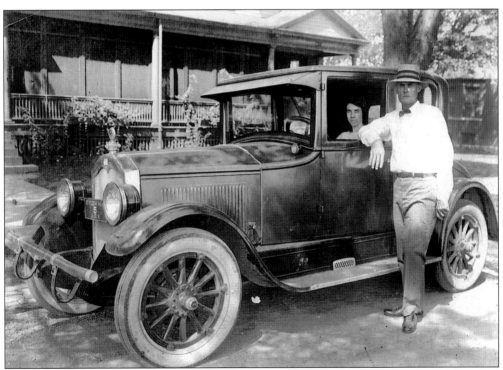

Charlie and Mary Carlin are pictured around 1925. (Courtesy of William Carlin White Collection.)

Carlin White is pictured at the age of 21. (Courtesy of William Carlin White Collection.)

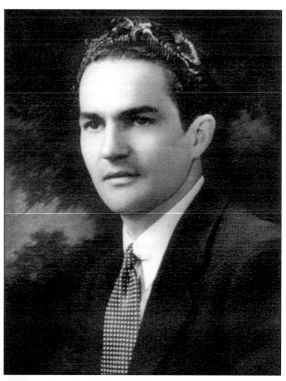

Pat and Madeline Carlin Williamson pose at the Carlin House in 1921. (Courtesy of William Carlin White Collection.)

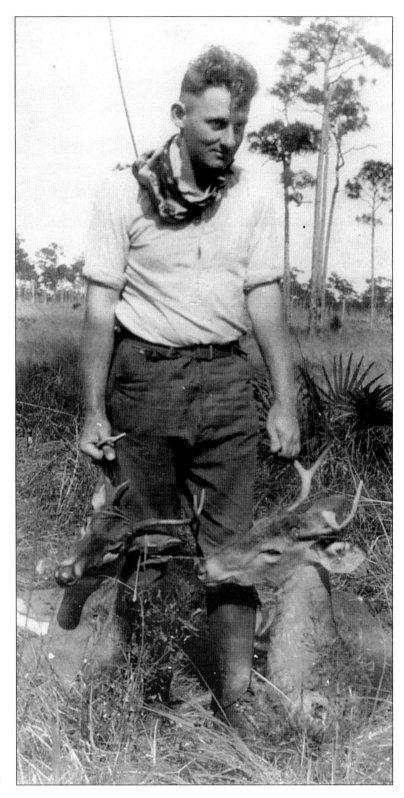

Harry Aicher is shown with the deer he shot around 1925. (Courtesy of William Carlin White Collection.)

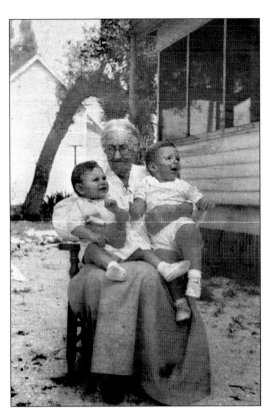

Grandma Carlin holds her great-grandsons, Tommy and Danny Ryan. (Courtesy of William Carlin White Collection.)

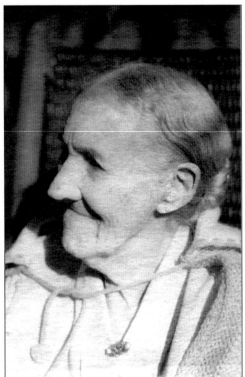

Grandma Carlin is photographed about 1940.

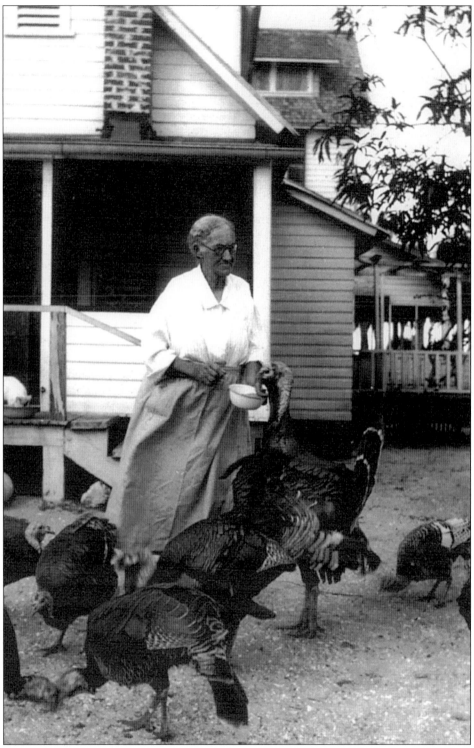

Grandma Carlin feeds turkeys at the Carlin House about 1930. The back steps of the kitchen are shown looking north. (Courtesy of William Carlin White Collection.)

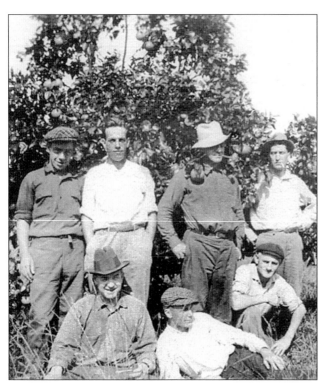

Harry Aicher, bottom right, visits with friends at the Lainhart Orange Groves in the 1920s. (Courtesy of William Carlin White Collection.)

In 1934, Old Daddy sits on the Carlin House Dock with his hatchet. Notice the fresh oysters under the dock that came from Peck's Lake. They were kept fresh for the Carlin House table. (Courtesy of William Carlin White Collection.)

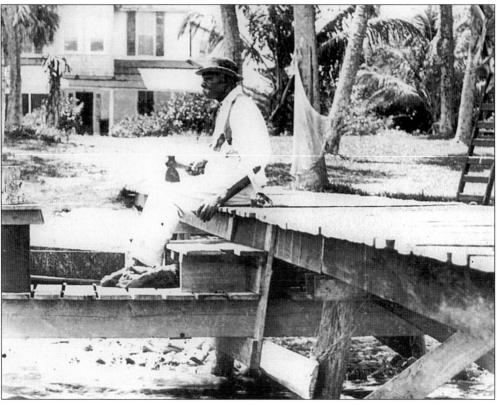

Lillian Oswald White, a journalist shown here at age 16, was born in Hicksville, Long Island, New York. She met Carlin while he was stationed near Hicksville in 1936. They were married in Fredericksburg, Virginia, on December 21, 1938. Two days later, Lillian saw Jupiter for the first time. They returned to Jupiter in 1969 when Carlin retired after 30 years in the military. Lillian wrote a newspaper column called the Loxahatchee Lament for many years, recording pioneer stories that culminated into a publication called *Loxahatchee Lament* in 1976. (Courtesy of William Carlin White Collection.)

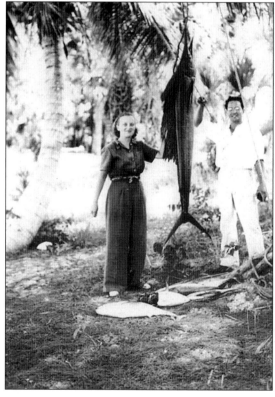

Lillian displays her first sailfish, caught while deep-sea fishing off Juno with Carlin on Paul Cone's boat in 1940. She had quite the sunburn. (Courtesy of William Carlin White Collection.)

Carlin White travelled to Freetown, Africa, in 1944. (Courtesy of William Carlin White Collection.)

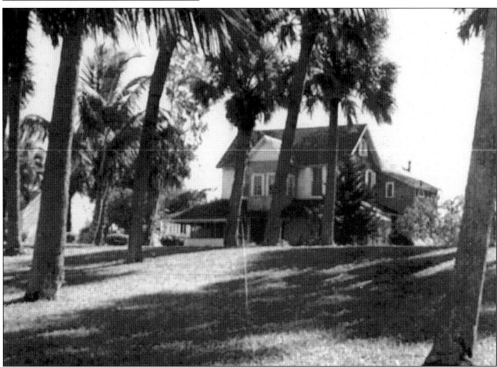

This is the Carlin House in 1927 with the east cottage to the left. (Courtesy of William Carlin White Collection.)

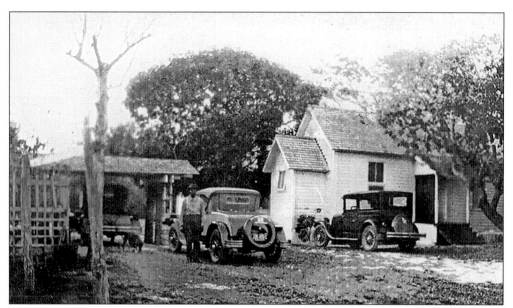

This picture, looking west, shows the back of the Carlin House with Old Daddy standing next to the car. (Courtesy of William Carlin White Collection.)

Lynn White, daughter of Carlin and Lillian White, is shown here with James Raby Jr. about 1945. (Courtesy of William Carlin White Collection.)

This photograph looks west toward the back of the Carlin House property. (Courtesy of William Carlin White Collection.)

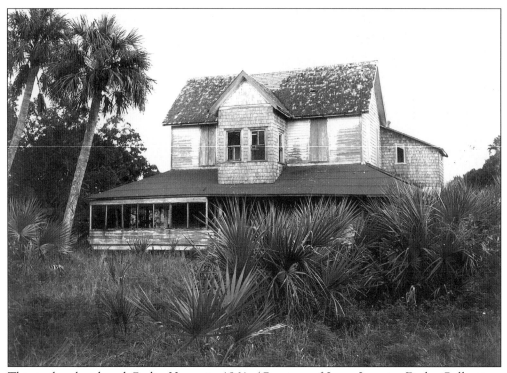

This is the abandoned Carlin House in 1961. (Courtesy of Lynn Lasseter Drake Collection. Photo taken by Franklin P. Lasseter.)

Four

CHURCHES, SCHOOLS, AND A COURTHOUSE

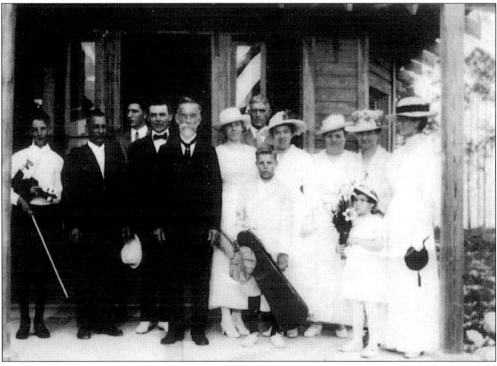

Rev. Charles Percival Jackson, Mr. Edward "Ned" King, and Fred Magill were all instrumental in organizing St. Martin's Episcopal Church in Jupiter in 1895. In 1910, Reverend Jackson and many of his followers moved south to the Coconut Grove and Homestead areas of Dade County. This 1916 photo of St. John's Episcopal Mission in Homestead shows, from left to right, Earl Mathews, Arundel "Rundy" Jackson (son of Dr. Jackson), unknown man in back, unknown man with bow tie, Rev. Charles P. Jackson, Pearl Skill, Mr. Stilling, Henry Brooker Jr. (with musical instrument), Mrs. Livingston, Mrs. Bow, Mary Elizabeth Krome (with bouquet of flowers), Mrs. Bredler, and an unknown woman.

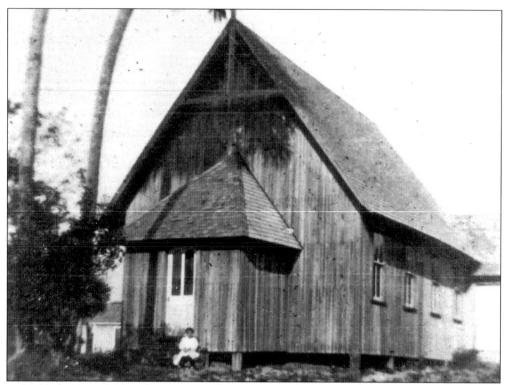

Mildred Carlin, oldest daughter of Charlie and Addie Damon Carlin, is shown sitting on the front steps of St. Martin's Episcopal Church, which was erected in 1899. This was the first actual church built in this area. Four years prior to that, Episcopalian services were held in the Octagon Schoolhouse, located where Smilin' Jack's Marina is now. St. Martin's was located right behind the Doster and Hooley (later Sperry) homes on the shell mound where the Suni Sands recreation hall is located today. (Courtesy of William Carlin White Collection.)

Harry Aicher built the home shown to the right of St. Martin's Church in 1913, when he was just 15 years of age. Grandma Carlin gave him the land and, with help, he built the house for about $600. The home is still in use today. (Courtesy of William Carlin White Collection.)

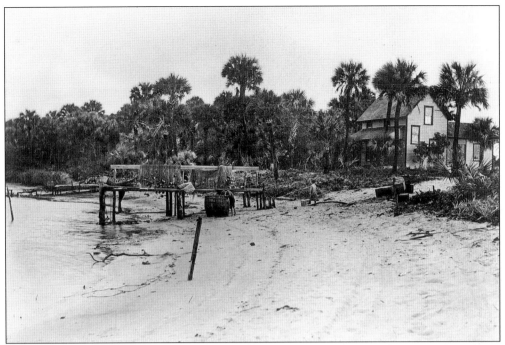

The Hattie West and William S. Tancre home, which once stood on the shore near St. Martin's Episcopal Church, is pictured about 1896. (Courtesy of Florida State Archives.)

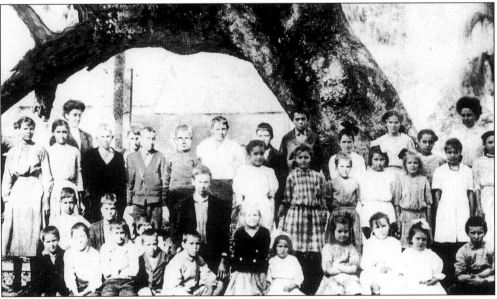

The school in the Ziegler house was started in 1901 after most families moved across the river to West Jupiter with the arrival of the Florida East Coast Railroad. Classes were held here until 1911, when plans were made to build a new school on Town Hall Avenue. John DuBois can be seen standing on the left side of the base of the tree in a dark suit. Neil DuBois is sitting in the front row, fifth from the left, next to the girl in the black sweater. The Ziegler family bought the small building originally built by Fred Cabot. They added on to it and used it as their home. The property is now Harbour View Park on the southeast side of Alternate A1A.

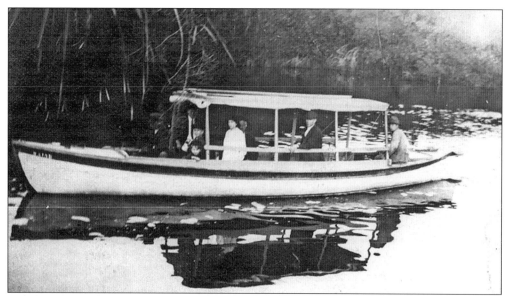

Nauman Carlin took this photo of the school boat *Maine* from the shore at the entrance to Sawfish Bay. (Courtesy of William Carlin White Collection.)

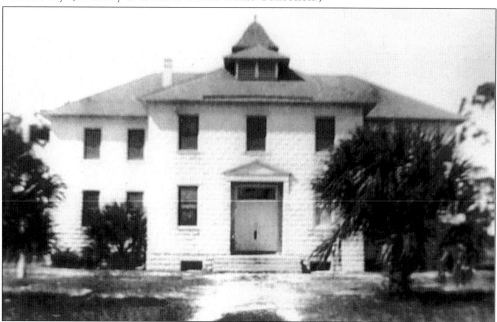

Jupiter's second real school building—after the Octagon Schoolhouse built in 1891—was called Pitchford School for principal Thomas Pitchford. Built in 1912 by James Hall, Jr., it was located where the old Town Hall Building still stands near Town Hall Avenue. The land was acquired from the Lucy Doster Miller Cronk homestead. The community held meetings in the upper story, the annual Christmas celebration was held there, and it served briefly as the Town Hall. In fact, Jupiter voters met at the school building to vote on incorporation. After the structure was determined to be flawed and unsafe, it was abandoned around 1926. This photograph was taken in 1921. A new schoolhouse was built on Loxahatchee Drive and is still standing. (Courtesy of William Carlin White Collection.)

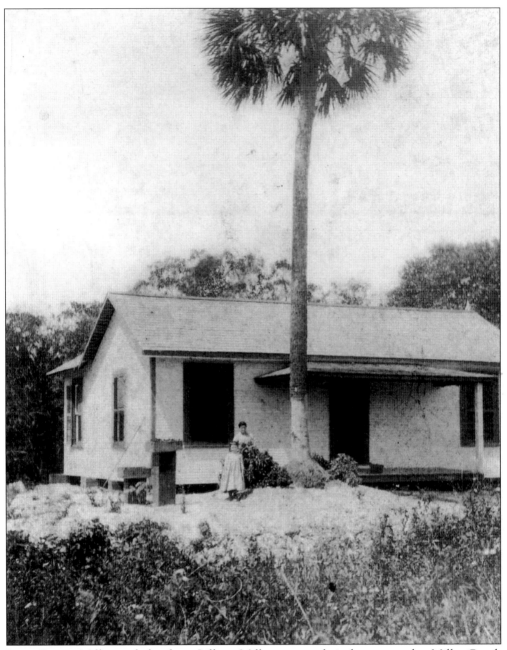

Lucy Doster Miller and daughter Lillian Miller are at their home on the Miller-Cronk Homestead. (Courtesy of Loxahatchee River Historical Society.)

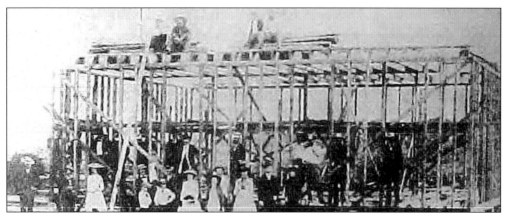

Construction of the Dade County Courthouse in Juno, Florida, began in 1889. (Courtesy of the William Carlin White Collection.)

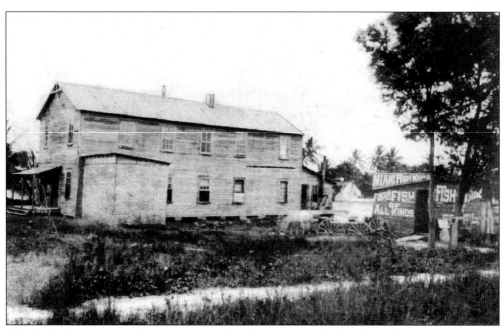

The Dade County Courthouse in Juno, Florida, is pictured after the Dade County seat was moved back to Miami. This building was located about a half mile north of the Celestial Railroad terminus at Lake Worth, near the location of today's Oakbrook Square on the northeast corner of PGA Boulevard and U.S. Highway 1.

The Union, or non-denominational, church was built by Herbert Pennock in 1922. Mr. Pennock donated this church to the community and each denomination met one Sunday out of the month. The church, located on Park Place, was the Southern Methodist Church for many years. It is now the First Presbyterian Church. (Courtesy of Lynn Drake Collection.)

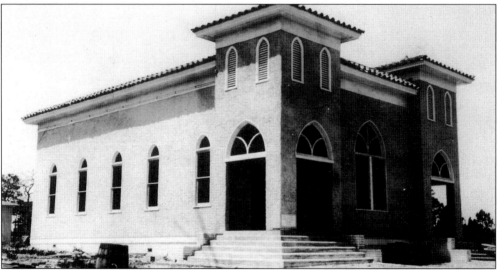

The People's Congregational Church was organized on April 1, 1917, and members worshipped in the old school building on Town Hall Avenue. In 1922, they were able to use the Union Church for services one Sunday a month. Wanting services every Sunday, the worshippers raised enough money to construct a church of their own. Church services in the new building began in June of 1924. (James Drayton Thompson Collection. Courtesy of Sue Dewey.)

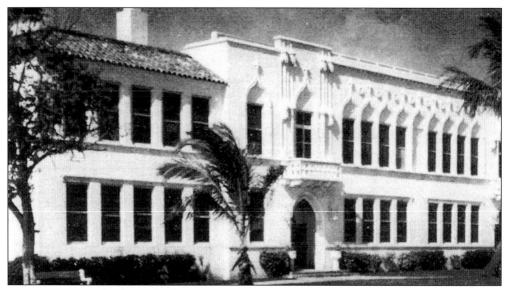

A new Jupiter School was built in 1927. This picture was taken in 1961 and the building was still in use until June of 2003. This old school building will be integrated into the newest Jupiter Elementary School site and may be used for administrative purposes. (Courtesy of Lynn Drake Collection.)

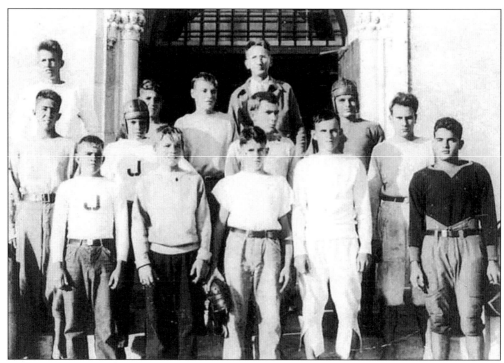

The Jupiter basketball team is pictured in front of the Jupiter School about 1933. Alfred Savage is leaning against the left side of the entryway, back row, second from left. All others are unidentified. (Courtesy of Pat Savage Inskeep Collection.)

Five
DuBois Family

Henry "Harry" DuBois, born in New Jersey in February of 1871, came to Merritt Island, Florida in 1887. Sailing his 40-foot-long sharpie through Jupiter Inlet delivering supplies to Palm Beach, he noticed the Indian shell mound. Harry settled here and became a member of the Jupiter Life Saving Crew for a while. He purchased the shell mound after proposing to Susan Sanders.

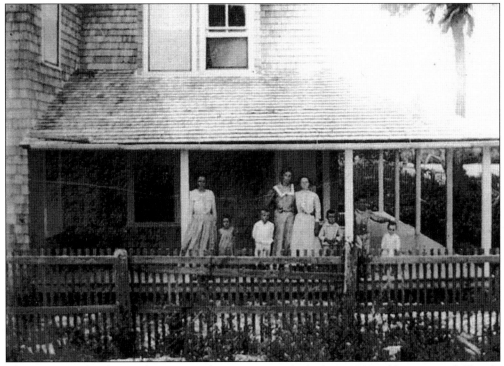

The DuBois family is shown on their east porch before 1910. (Courtesy of Florida State Archives.)

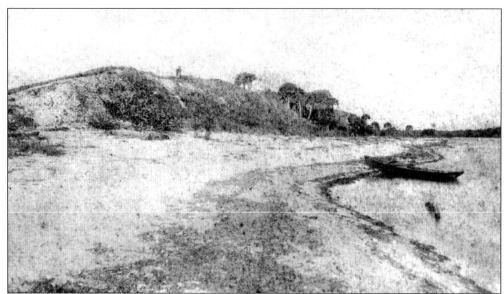

This is the original DuBois shell mound, once called Stone's Point, prior to 1895. David Stone, shipwrecked in his brig near Jupiter Inlet between 1842 and 1856, was our first recorded settler, or squatter as it may be, and seems not by choice. The wreck supposedly helped cause the inlet to close up for a time. According to an archeological and historical study of Jupiter Lighthouse Reservation by Jim Pepe, Stone's residence is briefly described in a March 5, 1857 letter written by Capt. Joseph Roberts: "Mr. Stone . . . has a house and garden on the south bank of Jupiter river near the inlet." Stone's residence was almost assuredly in what is now DuBois Park, and Bessie Wilson DuBois wrote that the DuBois property was once known as "Stone's Point." (Courtesy of Loxahatchee River Historical Society.)

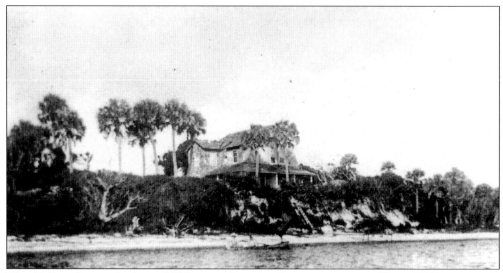

The DuBois home, built in 1898, started out with just one story. Harry DuBois married Susan Sanders, a schoolteacher at the Octagon Schoolhouse, in September 1898. The second floor was added when the couple began having children. (Courtesy of Loxahatchee River Historical Society.)

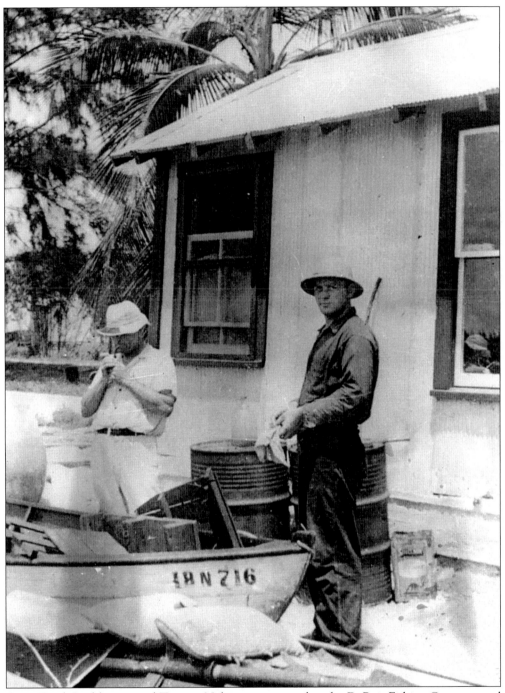

Capt. Frank Lechleitner and Trapper Nelson are pictured at the DuBois Fishing Camp around 1935. Captain Frank came to Jupiter in 1930 from Sebring, Florida. Prior to that he was a licensed steam engineer from Alberta, Canada. He operated his boat *Nine Bells* on the Loxahatchee River for many years. Frank was a friend of Trapper father, Casimir. (Courtesy of Skip Gladwin Collection.)

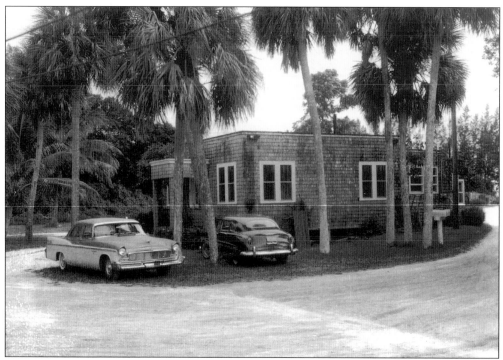

Bessie Wilson DuBois ran the DuBois Restaurant, located just a few feet from husband John's Bait and Tackle shop, which was situated on the waters edge at the DuBois Fishing Camp. (Courtesy of Loxahatchee River Historical Society.)

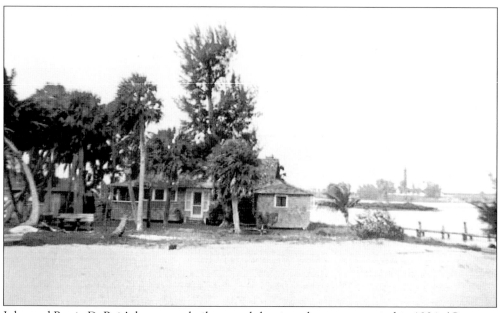

John and Bessie DuBois's home was built around the time they were married in 1924. (Courtesy of Loxahatchee River Historical Society.)

Six
SAILBOATS, STEAMERS, AND TRAINS

The Jacksonville, Tampa and Key West Railroad began its southward expansion from Jacksonville to Titusville in 1885. The company organized the Indian River Steamship Company just prior to the completion of the line to take care of the railroad's freight and passenger business from Titusville down the Indian River 120 miles to Jupiter Inlet. The Jupiter & Lake Worth Railway, known as the Celestial Railroad because of its stops in Jupiter, Mars, Venus, and Juno, was owned and built by the Indian River Steamship Company as a portage line connecting the Indian River with Lake Worth in what was then Dade County, Florida. Henry Flagler's Florida East Coast Railway bypassed the Celestial Railroad on its way south to Palm Beach in 1894, making travel on the large paddle wheel steamers obsolete.

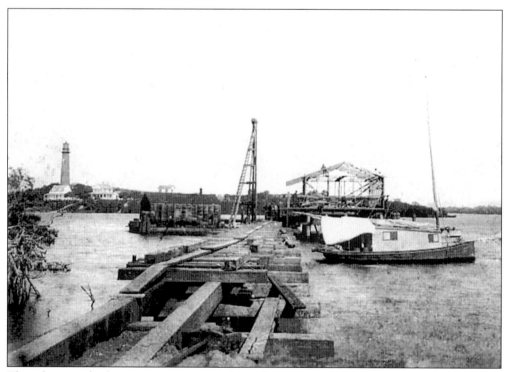

This photograph shows construction of the Celestial Railroad Dock, c. 1886. (Courtesy of Florida State Archives.)

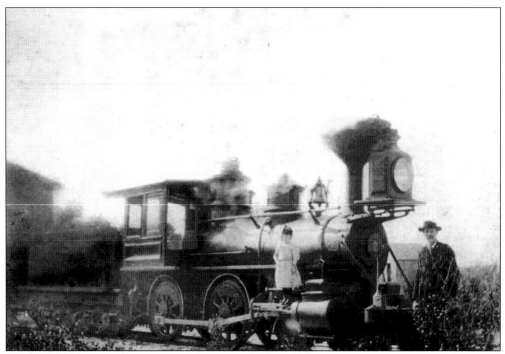

James Augustus "Gus" Miller and his daughter, Lillian Miller, were photographed standing on Celestial Railroad Engine #2, c. 1890. (Courtesy of Florida State Archives.)

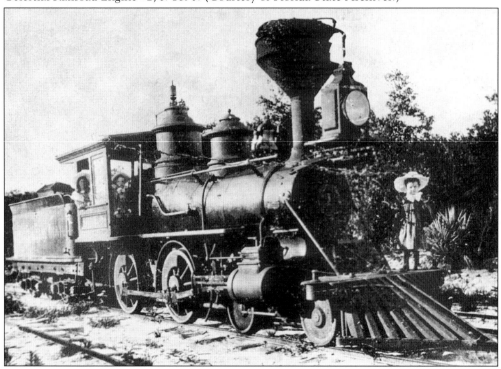

Lucy Doster Miller, Lillian Miller, and Dora Doster pose in Engine #1 about 1895. (Courtesy of Loxahatchee River Historical Society.)

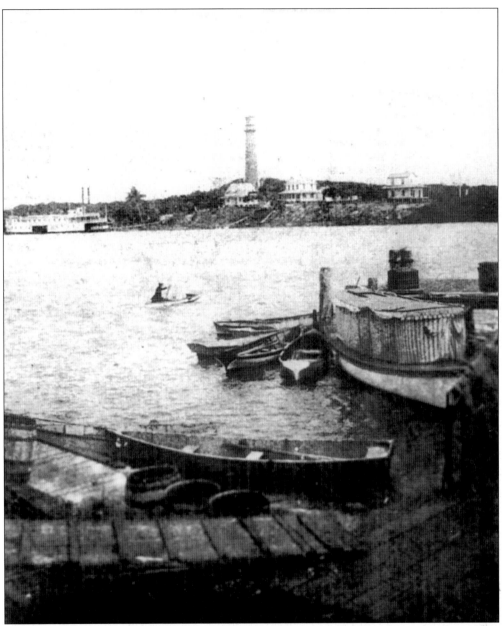

In 1891, the Celestial Railroad Dock was busy with all types of boat traffic, from large paddle wheel steamers to small skiffs. The dock was on the southern end of the Indian River and transportation had to continue over land on the little Celestial Railroad to connect passengers and supplies onto boats traveling south on Lake Worth, about eight miles south of the dock. (Courtesy of Historical Society of Palm Beach County.)

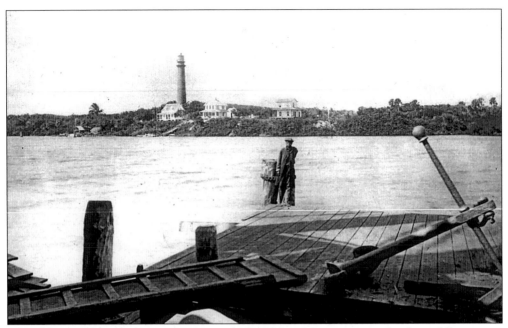

This unknown African-American man might be Milton Messer waiting for the paddle steamer at the Celestial Railroad dock, c. 1890. The keeper's quarters on the lighthouse property have not yet had the wraparound porches added and the Weather Bureau has not yet added the widow's walk as a third level. (Courtesy of Historical Society of Palm Beach County.)

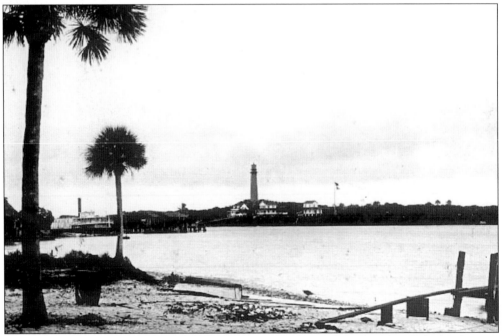

This is an 1890 view of a paddle wheel steamer at the Celestial Railroad dock, the two lighthouse keeper's dwellings, and the weather bureau, taken from the Carlin House property. The beginning of the Carlin House dock may be seen in the right foreground. (Courtesy of William Carlin White Collection.)

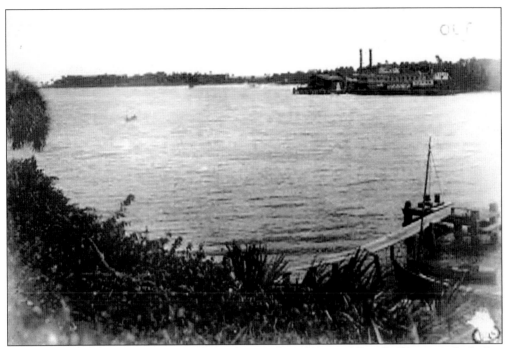

This southeastern view from the lighthouse property shows a paddle wheel steamer docked at the Celestial Railroad Dock around 1890. (Courtesy of William Carlin White Collection.)

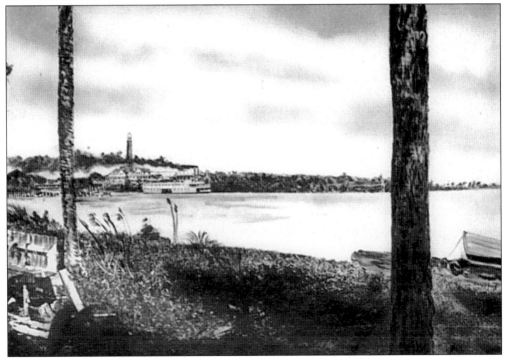

In 1890, a paddle wheel steamer leaves the Celestial Railroad Dock on its way north up the Indian River to Titusville and possibly Jacksonville. (Courtesy of William Carlin White Collection.)

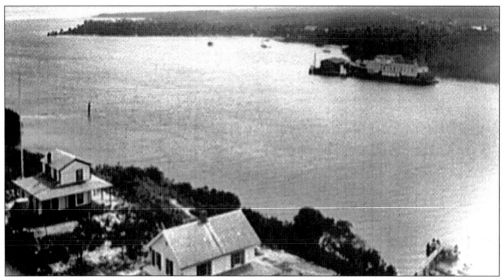

This photo, taken by William Henry Jackson in 1890, shows from left to right in the foreground the second keeper's dwelling, the original keeper's dwelling, and the lighthouse dock. In the background, from left to right, are the shell mound upon which Harry DuBois built his home, the Jupiter Lifesaving Station, the roof of the Carlin House, the Jupiter & Lake Worth Railroad Dock (better known as the Celestial Railroad), and a large paddle wheel steamer at the dock. Mr. Jackson stayed at the Carlin House on his trips to the area to take photographs for the Detroit Publishing Company. He stored an extra camera, glass plates, and equipment at the house for return trips to the area. Carlin White remembers these items in his grandmother's attic. Many years after the Carlin House was demolished and Emily Carlin White Turner passed away, her son Carlin found some of these glass plates stored in her attic. (Library of Congress, Prints and Photographs Division, Detroit Publishing Company Collection.)

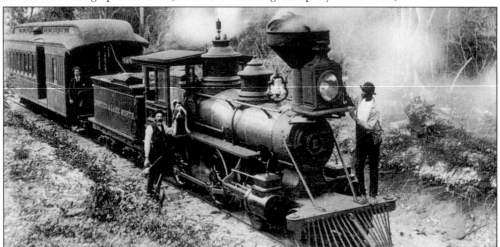

The Jupiter & Lake Worth Railroad Engine #2 is shown from the left with conductor Captain Matheson standing on the step of the half-passenger half-baggage car, Blus Rice standing alongside the engine holding the oil can in one hand and his hunting dog in the other, and Milton Messer polishing the headlight. Blus Rice was known to play "Dixie" on the steam whistle. (Courtesy of Library of Congress, Prints and Photographs Division, Detroit Publishing Company Collection. Photo by William Henry Jackson.)

90

An unknown oil man with the Celestial Railroad is photographed with a railroad car in the right background. This picture was taken just south of today's Art's Outboards. (Courtesy of William Carlin White Collection. Photo by William Henry Jackson.)

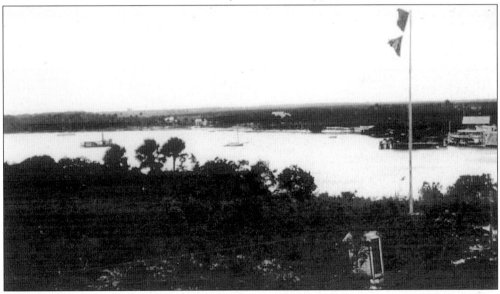

This photo, taken in the early 1890s from a survey tower on the lighthouse property, was probably taken by William Henry Jackson from Detroit Publishing Company. It shows the Jupiter & Lake Worth Railroad Dock (also known as the Celestial Railroad), a paddle wheel steamer, and Augustus James "Gus" Miller's hotel (behind the steamer). Dora Doster Utz, the niece of Lucy Doster and Gus Miller, wrote about these places in her story "Life on the Loxahatchee," published by Tequesta: The Journal of the Historical Association of Southern Florida in 1972. (Courtesy of Florida State Archives.)

A private steamer, the *Ibis* was moored in Jupiter sometime between 1890 and 1900 and probably photographed by Melville E. Spencer. (Courtesy of Florida State Archives.)

This photograph, taken by Indian River photographer Seth Shear, shows the Jupiter Narrows on the Indian River sometime in the late 1880s. (Courtesy of Skip Gladwin Collection.)

Walter Kitching traveled the Indian River in his 56-foot schooner the *Merchant* on the waterway near Jupiter about 1890. Designed as a trading vessel, the schooner allowed Mr. Kitching to provide and deliver much needed supplies to the settlers in the area. (Courtesy of Florida State Archives.)

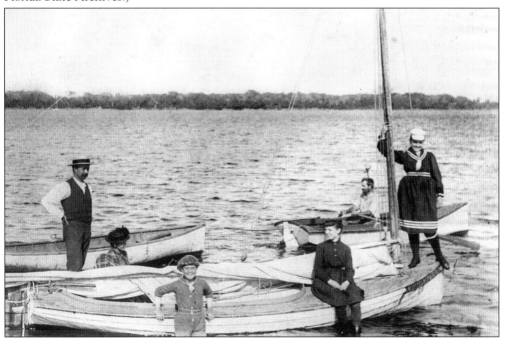

The Gale and Rowley families are photographed in Jupiter in the late 1880s. (Courtesy of Loxahatchee River Historical Society.)

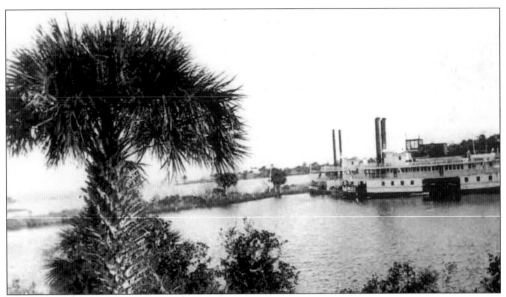

The *St. Sebastian* and *St. Augustine* anchor near the Jupiter area. Both of these paddle wheel steamers were owned by the Indian River Steamship Company. (Courtesy of Florida State Archives.)

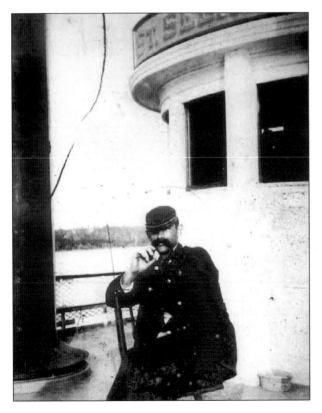

The steamer *St. Sebastian* was owned by the Indian River Steamship Company and sometimes captained by the infamous Steve Bravo, shown in this picture. *St. Sebastian* was scheduled to leave Titusville for Jupiter on Mondays and Thursdays at 3:20 p.m. and to arrive in Jupiter by 2:00 p.m. the following day. It was scheduled to leave Jupiter at 5:30 p.m. on Tuesdays and Fridays and to arrive in Titusville the following evening. The steamer was a double stack paddle steamer with double wheels. (Courtesy of Florida State Archives.)

Wood Landing at Jupiter Inlet was photographed by William Henry Jackson for the Detroit Publishing Company c. 1890. (Courtesy of Florida State Archives.)

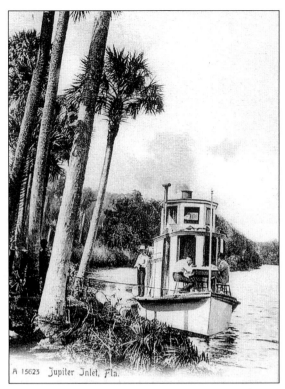

A 15623 Jupiter Inlet, Fla.

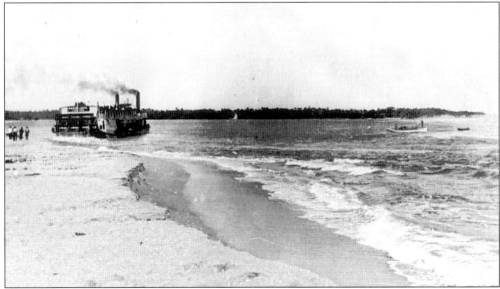

The *Santa Lucia*, shown in the Jupiter Inlet about 1890, was formerly the *Nellie Hudson*. Henry Flagler sent Captain Paddison to Pittsburgh to purchase and pilot home the large steamer that he needed to transport materials for the Royal Poinciana Hotel. The 3,000-mile trip down the Ohio River, to the Mississippi River, around Cape Sable, and through Jupiter Inlet to Titusville was a hazardous journey for the shallow draft steamer. The Jupiter Lifesaving Crew is seen standing by just offshore in their lifeboat. (Photo Courtesy of William Carlin White Collection.)

The *St. Augustine* was a double stack paddle steamer owned by the Indian River Steamship Company. On July 29, 1891, *The Tropical Sun* reported that Charlie Converse, an old time Melbourne boy, was holding down the pursership of the *St. Augustine*. The *St. Sebastian* and *St. Augustine* deteriorated in the upper reaches of the Loxahatchee River. (Courtesy of Florida State Archives.)

Jupiter's first Florida East Coast Railroad Depot was located at the southeastern end of the railroad span across the Loxahatchee River. To its east is the spur track going to Flagler's Florida East Coast Railroad warehouse and wharf. Flagler used this complex to unload material for his railroad and hotels further south. The two-story white building on the right is Bower's Store, owned by E. Frank Bowers. Frank came to Jupiter prior to 1908 and bought Ziegler's, the stock, and a building occupied by Brooker and Widmeyer. He ran a very successful store. Frank also bought the Widmeyer home and the Brooker Hotel (later called The Wayside Inn) north of the Ziegler property on Alternate A1A. This photo was taken about 1911. (Courtesy of Loxahatchee River Historical Society.)

Henry Flagler's Florida East Coast Railroad warehouse and wharf was located just east of where Jupiter Fisherman's Marina later stood. (Courtesy of William Carlin White Collection.)

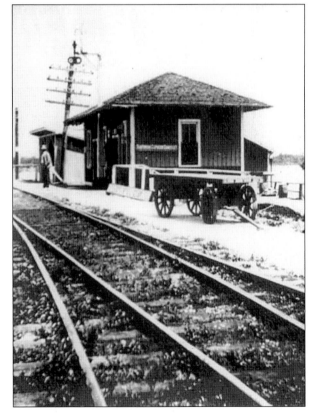

This is a photograph of Jupiter's first Florida East Coast Railroad Depot looking northeast. Henry Flagler's F.E.C. Railroad was finished through Jupiter into West Palm Beach by 1894. (Courtesy of Florida State Archives.)

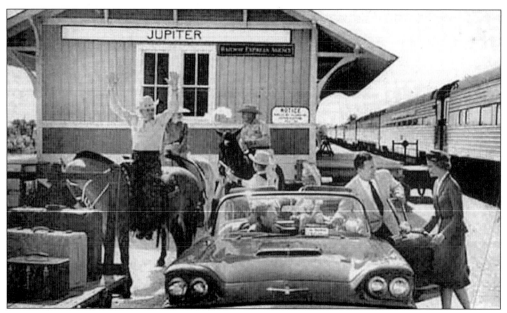

The Jupiter Florida East Coast Depot was located on the east side of the Florida East Coast railroad tracks, just north of Indiantown Road and across from Old Jupiter Beach Road. This Avis Rent-a-Car ad was published in *Life* magazine in 1960. Local resident Lige Mayo, father of police chief Glenn Mayo, can be seen with his hands in the air. Beau Mayo is on the horse to the right. (Courtesy of Bill & Patricia Magrogan.)

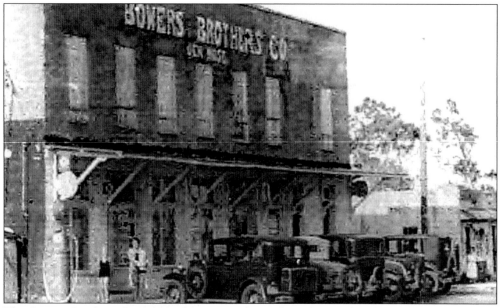

The Bowers Brothers Co.'s second store was located on the north side of Eganfuskee Street around 1941. The jail and post office were located east of the store. A fish house owned by the Martin family was located on the south side of Eganfuskee along the F.E.C. stub canal. Rex Albertson sold his machine shop, formerly located on the south side of the Old Dixie Highway bridge; it was also moved to the south side of Eganfuskee Street on the stub canal. (Courtesy of Loxahatchee River Historical Society.)

In 1911, Palm Beach County Commissioner E. Frank Bowers took as his project the construction of a bridge across the Loxahatchee River. The Old Dixie Highway Bridge was built of reinforced steel and concrete arches much like the railroad bridges to Key West. The arches rested on piling that was driven beneath the riverbed. This bridge was the scene of many violent confrontations with the owners of Model T's refusing to back up and give way on the turn about in the center of the bridge. This view of the bridge looking south shows Robert Jackson's Machine Shop with Boat Repair Shop on the first level. He later sold the shop to Rex Albertson. (Courtesy of Florida State Archives.)

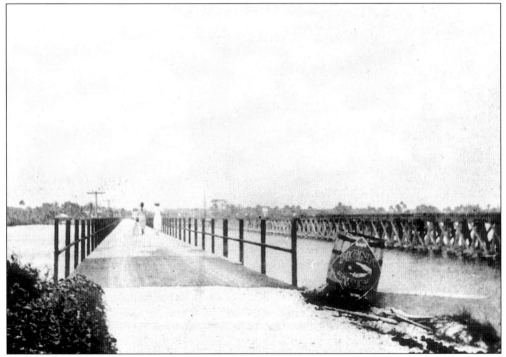

Two women are shown walking north on the Old Dixie Highway Bridge. (Courtesy of Carlin White Collection.)

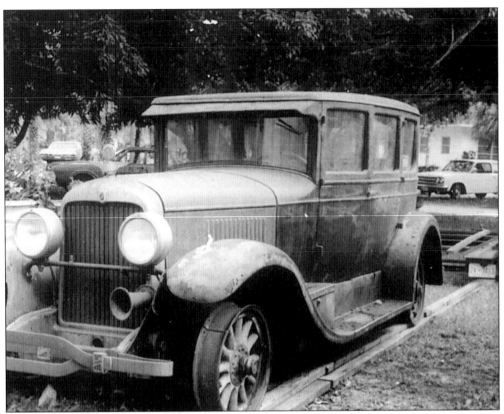

This image depicts Dr. Conn Aicher's 1929 Cadillac. (Courtesy of Carlin White Collection.)

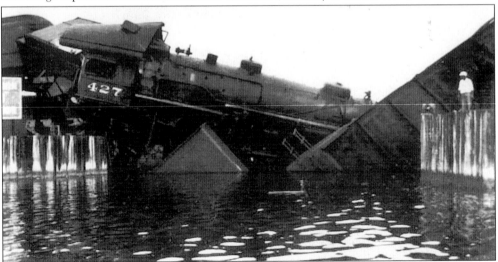

In 1934, the southbound Florida East Coast Railroad engine #427 struck the upright bridge crossing the Loxahatchee River. The collision pushed the counterweight and upright portion of the bridge into the river. Carlin White was on a boat on the west side near the railroad bridge taking pictures with his movie camera when the train approached the open span. With camera in hand, he watched the whole thing happen and forgot all about taking a picture. Two hobos and another man were able to jump clear. (Courtesy of William Carlin White Collection.)

Seven

SUNI SANDS

In the late 1890s, Edwin S. Hooley, a prominent man in the New York Stock Exchange, built his winter home on property just west of the Carlin House. Among his guests were Mr. and Mrs. William M. Sperry. Mr. Hooley sold the house on July 28, 1904, to Emily L. Sperry, wife of William Sperry. Mr. Sperry, of Sperry & Hutchinson Green Stamp fame, continued to develop his estate and named it "Suni Sands." Sperry acquired as much property as he could around his winter home. His property had 21 sweet water wells, two orange groves, five cottages, a large garden, and a nature trail surrounding the property.

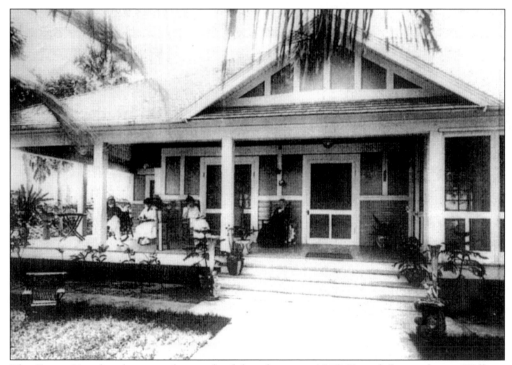

The Sperry Family relaxes on the porch of their home in 1907. From left to right are William Sperry, Lola, Carrie, and Grandma Sperry. It is their first day there. (Courtesy of Loxahatchee River Historical Society.)

This photograph, taken about 1904, shows the shell mound upon which the Sperry home stood. Emily Sperry purchased the home from Edwin S. Hooley in 1904. William and Emily Sperry named their winter estate "Suni Sands," and after renovating the home in 1907, they built a

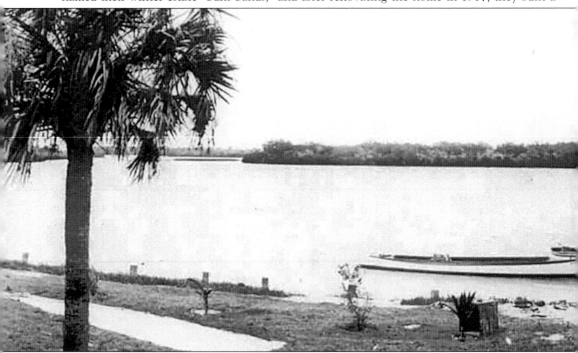

This northerly view from the Sperry home shows the original Hooley dock, the southern terminus of the Indian River (now the Intracoastal Waterway) to the left, and Jupiter Inlet to

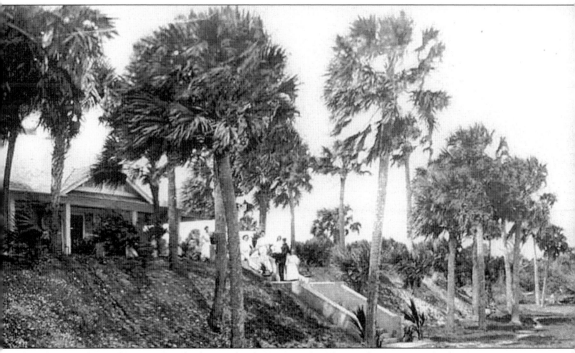

boathouse where the existing dock stood. The Sperry family can be seen on the home's steps, which are still standing in today's Suni Sands Trailer Park. (Courtesy of Loxahatchee River Historical Society.)

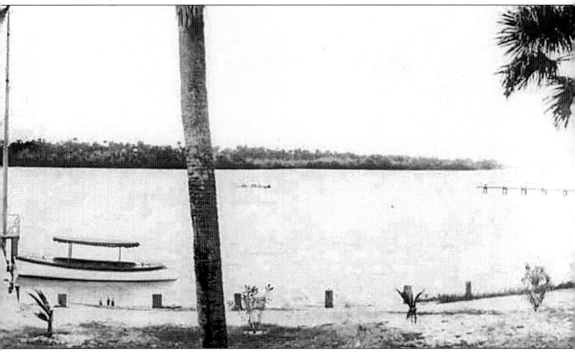

the right. (Courtesy of Loxahatchee River Historical Society.)

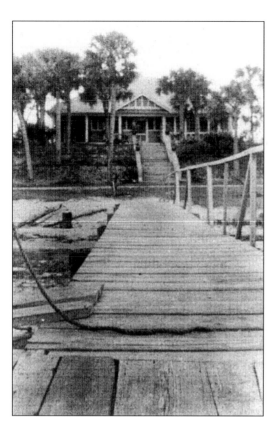

This view of the Sperry home around 1905 shows the original dock. (Courtesy of Loxahatchee River Historical Society.)

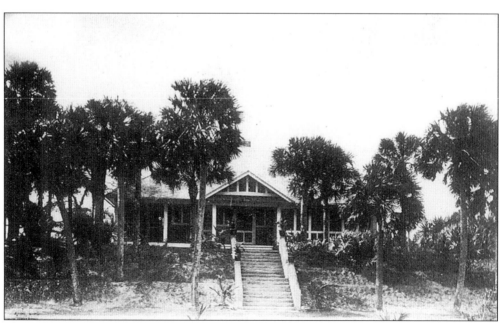

This image depicting the front view of the Sperry home was taken around 1907. (Courtesy of Loxahatchee River Historical Society.)

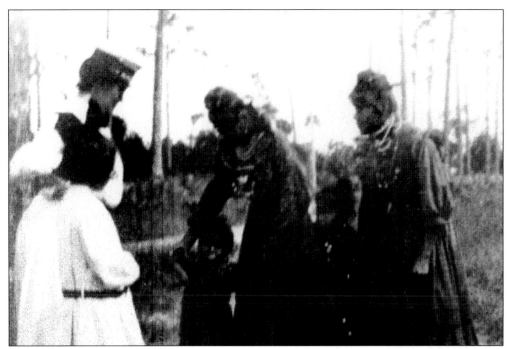

Mrs. Sperry and her daughter Dorothy visit with Seminole women and their children on Old Dixie Highway about 1917. (Courtesy of Loxahatchee River Historical Society.)

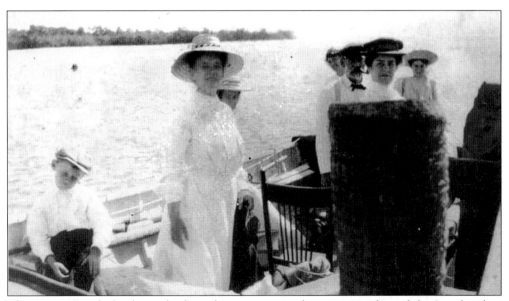

The Sperry Family loads up the boat for a picnic on the upper reaches of the Loxahatchee River. From the left, Harry Aicher looks rather out, his mother Ella Carlin Aicher is sitting behind the unidentified woman in the white hat, and Mr. And Mrs. Sperry can be seen standing behind the palmetto piling. The two people in the back of the boat are also unidentified. Jupiter Inlet is at right. (Courtesy of William Carlin White Collection.)

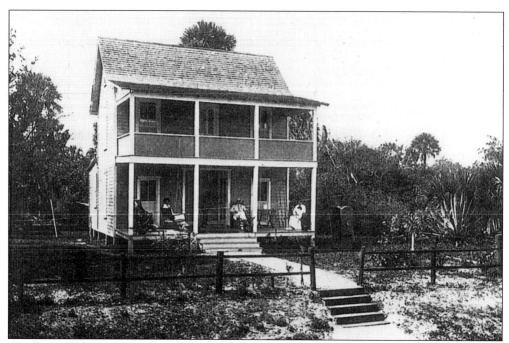

This is the two-story cottage on Sperry's Suni Sands estate, located near what is now A1A. (Courtesy of Loxahatchee River Historical Society.)

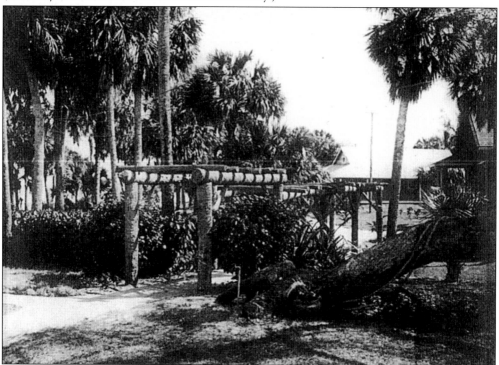

This pergola behind the main Sperry cottage was usually covered by bougainvillea. The tree leaning to the right still stands behind the Suni Sands recreation hall. (Courtesy of Loxahatchee River Historical Society.)

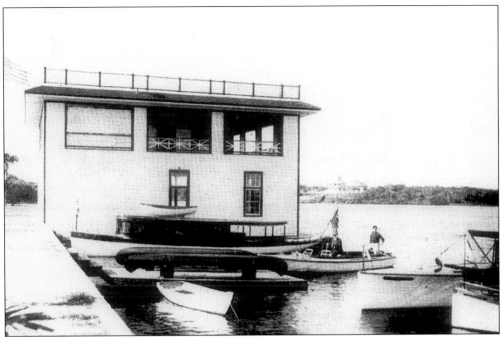

In this 1907 photograph, the Sperry boathouse and ballroom are shown with several of the Sperry's boats. It is not known if the ballroom, located on the upper floor, ever got much use in the little village of Jupiter. (Courtesy of Ray Haas Collection.)

Charlie Carlin, William Wright, Uncle Joe Russell, and William Sperry visit on the Carlin House dock about 1907. (Courtesy of Loxahatchee River Historical Society.)

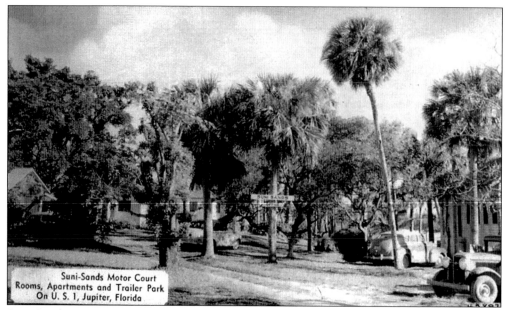

Suni Sands Motor Court is pictured c. 1949; several cottages were still standing at that time. (Courtesy of Lynn Lasseter Drake Collection.)

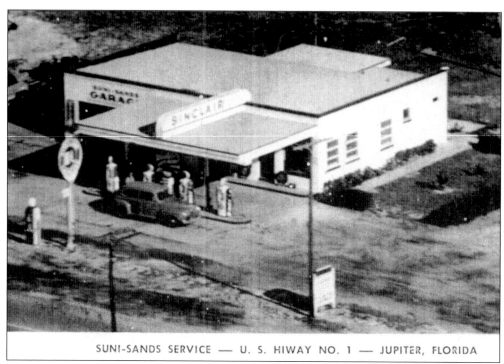

Suni Sands Garage, a Sinclair gas station, was located on what was then U.S. Highway 1, 1951. (Courtesy of Skip Gladwin Collection.)

Eight
WEST JUPITER

The entire area was called Jupiter until 1894 when Henry Flagler brought his Florida East Coast Railroad south through Jupiter to West Palm Beach. Prior to 1894, there were no bridges to connect the different areas on either side of the river. Travel was done by way of the water and all manner of sea craft could be found in the river: steamboats, sailboats, rowboats and more. Flagler's railroad had put an end to the usefulness of the little Celestial Railroad. Settlers moved their businesses and homes to the west side of the river to have access to the railroad. To avoid confusion, this area was called West Jupiter.

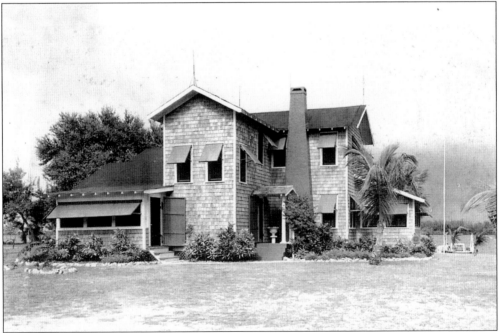

Emily Carlin White married Fred Turner in September 1921. They built this home on the Loxahatchee River, which took several years to complete. They first built a garage to the east of the home site with a small apartment above it. They lived in the apartment while building their home, and when their home was completed, they sometimes rented the house during the season and stayed in the small apartment. (Courtesy of William Carlin White Collection.)

J. Fred Turner Jr. worked as a general line salesman for Chitty & Co. of Jacksonville, Florida, a grocery house and beverage distributor who supplied grocers on the east coast of Florida. This photograph was taken about 1919. Fred was also a traveling salesman for the Peninsula Naval Supply Company of Jacksonville. (Courtesy of William Carlin White Collection.)

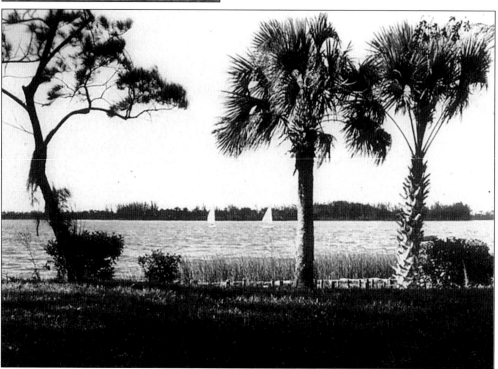

From the backyard of the Turner home, looking northerly across the Loxahatchee River toward what is now Riverside Drive, the Thayer family is seen with their two sailboats in the distance. (Courtesy of William Carlin White Collection.)

The south cottage on the Turner property was once the turkey house. It was later used as an apartment for many years. (Courtesy of William Carlin White Collection.)

Fred and Emily Turner stand in front of one of the old fern sheds on Turner Quay in March 1951. (Courtesy of William Carlin White Collection.)

Rebecca Anderson Simmons, Mary Anderson Davis, and Emma Anderson Herman were three of ten known children born to Gracie Terry and Moses Anderson in Tallahassee, Florida. Philip Simmons homesteaded 160 acres on the North Fork of the Loxahatchee River in March 1904 and married the widow Rebecca Anderson Harris in September 1904. L.M. Davis asked Rebecca Anderson Simmons, wife of his friend Philip Simmons, if she had any sisters just like her. She must have said "yes" because he began corresponding with Mary Lee Anderson by mail. They met in 1903 on the day they were married in her hometown of Tallahassee. L.M. and Mary homesteaded 159.96 acres on the northwest side of the end of Limestone Creek Road in May 1915. Emma Herman lived in Jacksonville. (Courtesy of Georgia Mae Davis Walker.)

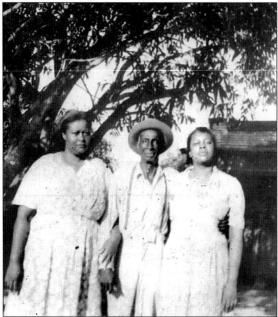

Ella Louise Davis McNealy, Elton Brown, and Gladys Davis Alleyne are shown at the old Davis home place on Limestone Creek Road. Ella and Gladys were the daughters of L.M. and Mary Davis; Elton was L.M.'s brother. (Courtesy of Georgia Mae Davis Walker.)

Georgia Mae Davis and Ollie Preston strike quite the pose in this photo taken about 1932. Georgia Mae, the daughter of Mary and L.M. Davis, married Johnny Walker in April 1944. Ollie, the daughter of Robert T. and Viola Preston, moved with her family to Jupiter from San Mateo, Putnam County, Florida, before 1930. (Courtesy of Georgia Mae Davis Walker.)

Ella Mae Ford, daughter of Kinsey Ford and Ada Belle Sapp, was born in November 1927. Her grandfather Robert Small Sapp came from Barnwell County, South Carolina, to Jupiter about 1925. Kinsey Ford, son of Rev. James Corry Ford Sr. and Ella Regina Ford, came to the Jupiter area in 1921 from Blakely, Early County, Georgia. (Courtesy of Georgia Davis Walker.)

This photo, taken about 1949 near what is now Military Trail just south of Toney Penna Drive, shows Abe Davis Jr., Marvin Davis, Charles Davis, and an unknown child in the wagon. Around that time, Abe Davis Sr. was doing work for a man named Thompson. (Courtesy of Georgia Davis Walker.)

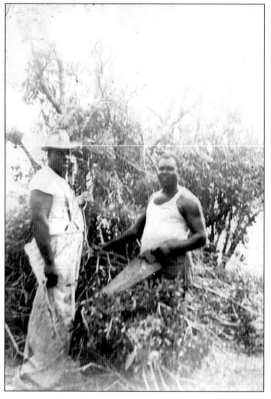

Johnny Walker and L.J. "Fats" Young work hard clearing land in the Limestone Creek area. (Courtesy of Georgia Davis Walker.)

L.J. "Fats" Young, born in Vidalia, Georgia, in 1919, came to the Jupiter area sometime before 1953. (Courtesy of Rebecca Davis.)

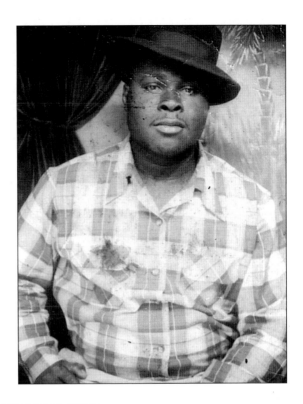

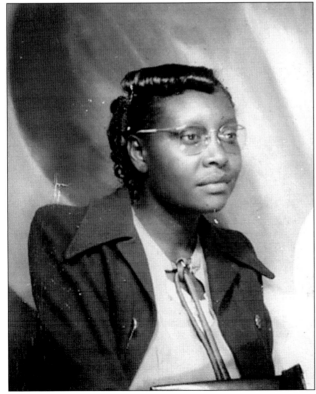

Nancy Davis Young, the ninth and youngest child of Mary Anderson Davis and Louis Moseley "L.M." Davis, was born in the Davis home on Limestone Creek Road in the summer of 1922. Nancy married L.J. Young Sr., and they had six children. Nancy visited Chicago in 1949 and stayed when she was offered a job at the Stotler Hotel. This photograph was taken while she was in Chicago. (Courtesy of Nancy Davis Young.)

115

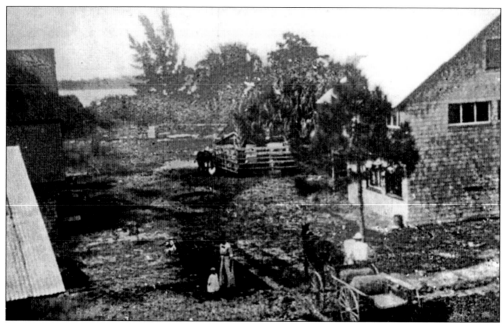

This photo of the Pennock barnyard was taken from one of the many windmills on the plantation in March 1913. The Loxahatchee River can be seen at the back of the property. (Courtesy of William Carlin White Collection.)

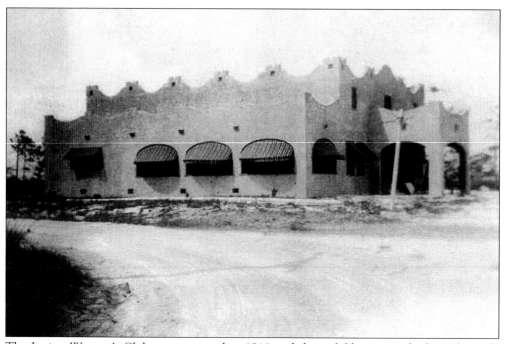

The Jupiter Women's Club was organized in 1911 and their clubhouse was built in the early 1920s. Located where Evernia Street and Orange Avenue intersect, just west of Lainhart & Potter, the building was used as a U.S.O. during World War II. It burned to the ground in 1950. (Courtesy of William Carlin White Collection.)

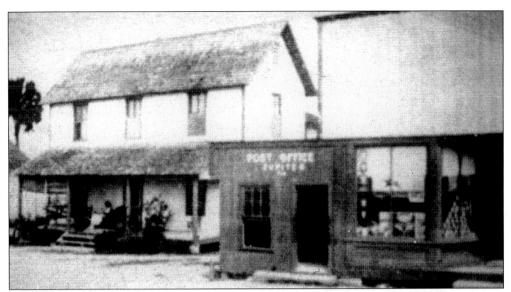

The Jupiter Post Office, built about 1894, was located on the east side of Old Dixie Highway, east of the FEC railroad tracks. Photographed in 1912, from left to right, are the Jupiter Hotel, Wayside Inn, the first Frank Bowers residence, the post office, and Ziegler's Store. (Courtesy of William Carlin White Collection.)

Dressed for a Sunday picnic, these Jupiter pioneers were photographed at Joe Bowers Orange Grove in 1921. The following are pictured from left to right: (front row) Lillian Oglesby's sister, Bessie Wilson, Emma Pitchford (wife of Thomas Pitchford), Inez "Lucy" Oglesby Bowers (wife of Frank Bowers), and Kelly Oglesby; (back row) Dorothy Adkins, Bruce Womack, John Wilson, Thomas Pitchford, and Lillian Oglesby. (Courtesy of William Carlin White Collection.)

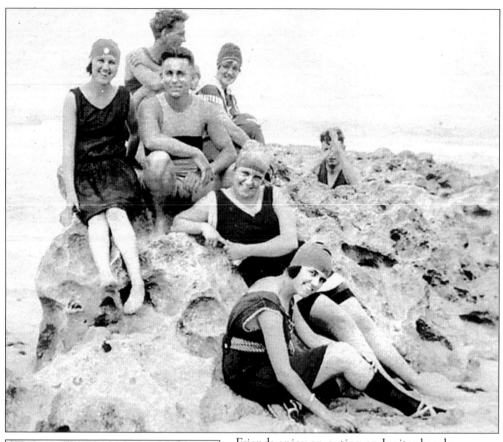

Friends enjoy an outing on Jupiter beach. Pictured from left to right are (front row) two unknown girls; (middle row) Myrtle Barfield and Harry Aicher; (back row) an unknown man looking to the right, an unknown girl, and an unknown man behind rock. (Courtesy of William Carlin White Collection.)

Myrtle Barfield, daughter of Samuel and Pinnie Osteen Barfield, met Harry Aicher when her family returned to Jupiter in 1912 after being away for a few years. John DuBois recalled that Sam had a fish house in Jupiter around 1911. Sam had about five or six boats and as many men gathering and opening oysters. The inlet closed about that time and all the oysters died. Myrtle and Harry were childhood sweethearts. Myrtle married Joe Roberts in 1924 and they had two children, Marian and Jack. (Courtesy of William Carlin White Collection.)

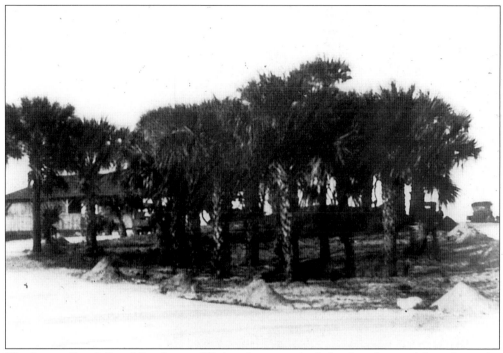

The Jupiter Beach Road Pavilion is filled with cars and sabal palms. Located directly on the beach on the east end of Jupiter Beach Road, it was probably built around 1920. The pavilion blew away in the hurricane of 1926. (Courtesy of William Carlin White Collection.)

Jupiter Beach Road Pavilion shelters unknown beachgoers prior to 1926. (Courtesy of William Carlin White Collection.)

Jean Hepburn sits in the first car that Carlin White built from a frame given to him by Frank Bowers in 1926. A longtime schoolteacher, Jean never married. She was the daughter of Mary Grant Hepburn and James S. Hepburn. James came to Jupiter in 1888 and brought his wife in 1889. (Courtesy of William Carlin White Collection.)

The Shuflin family came to Jupiter from Ohio in 1913. Frank Shuflin Jr. is pictured with unidentified friends about 1923. He later became an architect in Miami. (Courtesy of William Carlin White Collection.)

The Minear Boys, shown in 1936, were the children of Anna Pennock Laird and Lloyd Minear. (Courtesy of William Carlin White Collection.)

Charlie Baird is pictured with his 1933 Ford. He came to Florida in 1933 as a second class radio operator in the navy, assigned to the Jupiter Radio Naval Station. In 1936, he went to work for the F.A.A., first at the old Morrison Field and then at the control tower of the Palm Beach International Airport. After retiring in 1966, Charlie became involved with the local fire department, where he later served as chief. (Courtesy of William Carlin White Collection.)

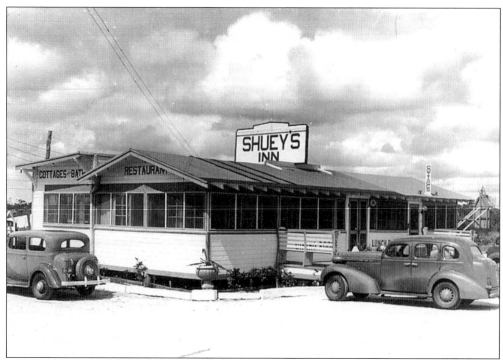

Shuey's Inn Restaurant, shown here with vintage cars, was owned and operated by Otto Schumacher. He advertised a large airy dining room, quick service, and "the best fish dinners in Florida." (Courtesy of Skip Gladwin Collection.)

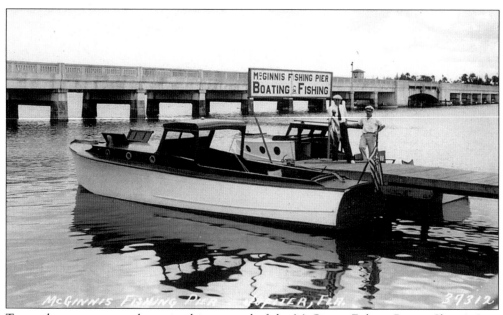

Two unknown men are shown in this postcard of the McGinnis Fishing Pier at Shuey's Inn. One may be Capt. Frank McGinnis. Frank was a well-known fisherman in the Jupiter area. His dock was located on the northwest side of the original United States Highway #1 bridge. The old dock pilings can still be seen at low tide. (Courtesy of Lynn Drake Collection.)

Shuey's Inn, Cottages, and Restaurant, located on the northwest side of U.S. Highway 1, also had a gas station. Otto Schumacher advertised cottages that were large, airy, and heated, with private baths, hot and cold showers, and innerspring mattresses. (Courtesy of Skip Gladwin Collection.)

Shuey's Trailer Park and Cottages also had a fishing pier. They had all kinds of boats for rent, from rowboats to ocean-going boats, bait and tackle of all kinds, and a sightseeing trip up the Loxahatchee River. Trapper Nelson's zoo was the highlight of the trip. (Courtesy of Skip Gladwin Collection.)

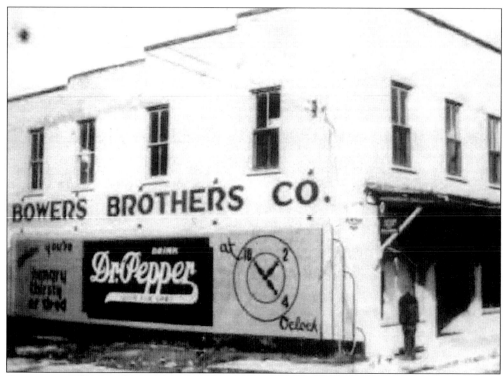

Bowers second store, photographed in the 1950s, was located on the north side of Eganfuskee Street. In later years the building housed Treasures and Trifles Antiques. It was demolished in the late 1980s. (Courtesy of Loxahatchee River Historical Society.)

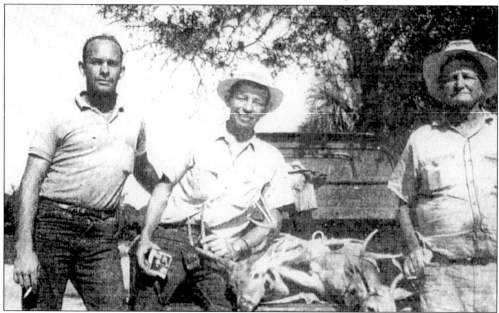

Louis Freeman, Jimmy Bassett, and Schley Savage are shown with two deer they shot in the J.W. Corbett Wildlife Management Area on the first day of open season before noon. John and Guy Freeman had accompanied them on this hunting trip. (Courtesy of Skip Gladwin Collection.)

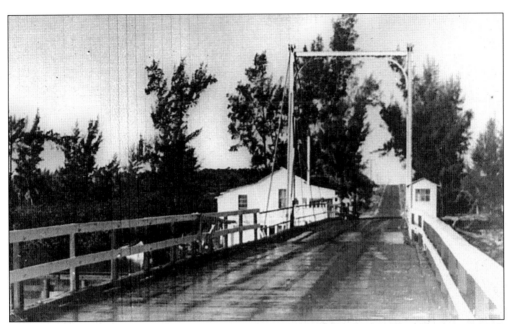

Built around 1920, the bridge on State Road 707 crossed the Intracoastal Waterway to Jupiter Island. Once called Wood's Bridge for William C. Wood, a previous bridge tender, the bridge is still sometimes referred to as Cato's Bridge. The bridge as it appeared in 1955 was a narrow wooden swinging bridge that was operated by hand. (Courtesy of DeeDee Cato Nittolo.)

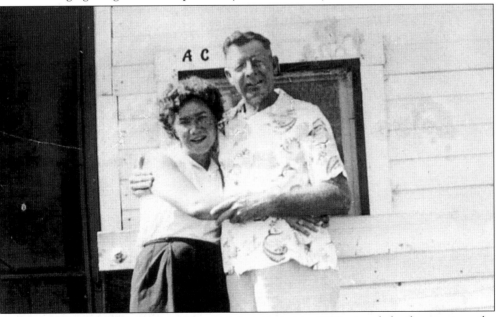

Avon Cato moved his family from Vero Beach to Jupiter in 1948 to work for the county as the bridge tender on the State Road 707 bridge. Avon and Mary Sue Cato tended the bridge for 17 years. Avon's children from his deceased wife Iva Mae Cato; Shirley, Ron and Bob, all lived with them in the bridge tenders house that was fronted by dry land while the back half sat out over the water on pilings. Mary and Avon are pictured in front of the bridge tender's house, c. 1955. (Courtesy of DeeDee Cato Nittolo.)

The Bridge Club met at Evelyn Bogardus Ziegler's home on Northwood in 1929. Pictured from left to right are (front row) Bessie Wilson DuBois, Mildred Rood Yates, Gwyn Rood Merello, Casilda Tomasello Wilson, Ruth Hamm, Shirley Pennock Floyd, Grace Wilson Christensen, and Alma Aicher Holden; (back row) Anna DuBois Nelms, Mrs. Bogardus, Emily Carlin Turner, and Mrs. Henry Pennock. (Courtesy of William Carlin White Collection.)

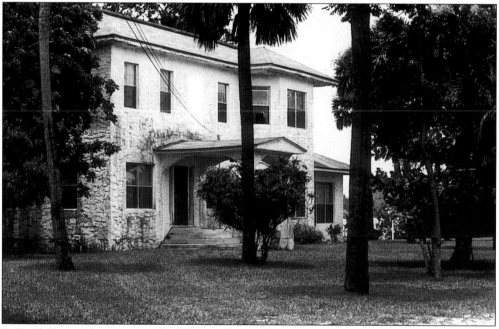

E. Frank Bower's home on north Old Dixie Highway was photographed in 1985. The once run-down home has been beautifully restored. (Courtesy of Lynn Drake Collection.)

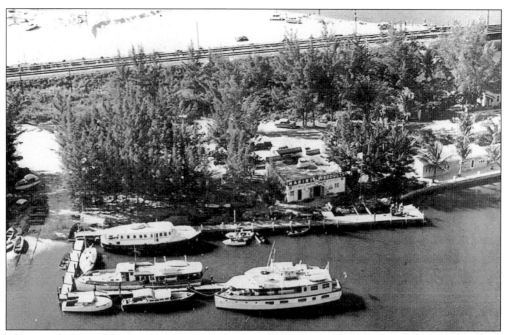

This aerial view of the Jupiter Marina was taken about 1949. The marina was located between Beacons 3 and 5 and offered the following 24-hour services: white and diesel gas, boat launching, picnic grounds, store, snack bar, and mechanic. For many years, local fisherman could be seen weighing in their catch. This was always a social event for area residents and visitors. (Courtesy of William Carlin White Collection.)

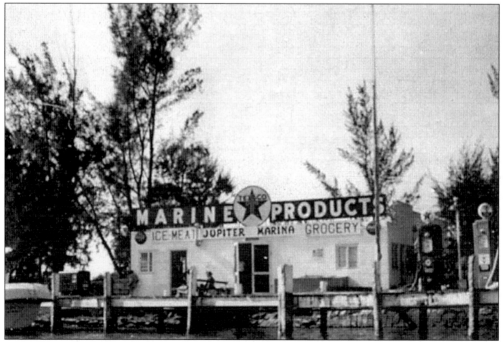

The Jupiter Marina Marine Products Store is seen in this 1949 postcard. In later years it became a popular locals' restaurant. (Courtesy of Lynn Drake Collection.)

Trapper Nelson is shown in this 1950s photograph with an unknown boy in a boat on the Loxahatchee River. (Courtesy of Skip Gladwin Collection.)

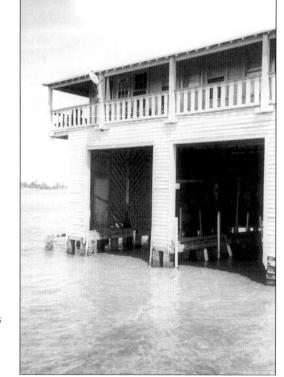

This photo of the Suni Sands Boathouse was taken in the summer of 2002. At present, the tenants have moved out and a complete restoration of the boathouse is planned. The boathouse is also trying to get historic designation. (Courtesy of Lynn Drake Collection.)